G000066902

CORNWALL'S
MILITARY HERITAGE

CORNWALL'S
MILITARY HERITAGE

Andrew Powell-Thomas

AMBERLEY

For Lorna & Ben Crouchen, Hana Laplanski and Damien Tozer.

First published 2022

Amberley Publishing
The Hill, Stroud
Gloucestershire, GL5 4EP

www.amberley-books.com

Copyright © Andrew Powell-Thomas, 2022

Logo source material courtesy of Gerry van Tonder

The right of Andrew Powell-Thomas to be identified
as the Author of this work has been asserted in
accordance with the Copyrights, Designs and Patents
Act 1988.

ISBN 978 1 4456 9501 3 (print)
ISBN 978 1 4456 9502 0 (ebook)

All rights reserved. No part of this book may be
reprinted or reproduced or utilised in any form
or by any electronic, mechanical or other means,
now known or hereafter invented, including
photocopying and recording, or in any information
storage or retrieval system, without the permission
in writing from the Publishers.

British Library Cataloguing in Publication Data.
A catalogue record for this book is available from the
British Library.

Typesetting by SJmagic DESIGN SERVICES, India.
Printed in Great Britain.

Contents

Introduction

Cornwall has rolling hills, national parks, vast swathes of farmland and stunning coastline everywhere you look – but it also has a rich military heritage hiding in plain sight. Iron Age hill forts are scattered across the county, and while most have been reclaimed by Mother Nature, they're still visible if you look closely. Castles and fortified manor houses sprung up over the centuries as defensive centres of power for the rich and influential, often used to keep the locals in check and to defend the ports and harbours from intruders.

As proud Celts, there were a series of uprisings that took place over the years, including the battles fought between the Royalists and the Parliamentarians during the English Civil War. Palmerston Forts were built to protect the ports and English Channel from the advances of the French, with many existing castles upgraded to handle this threat.

The names of hundreds of young men who set off from the quiet life in Cornwall, never to return from the horrors of the First World War, are immortalised on the silent monuments that adorn nearly every town and village, and the heritage of the Duke of Cornwall's Light Infantry is well documented. The Second World War saw armament factories, airfields, camps, defensive emplacements, as well as prisoner-of-war camps, built the length and breadth of the county, with some towns facing German aerial bombardment as well as an influx of servicemen and women as the Allies prepared for D-Day.

Training centres and operational bases are still used today, ensuring that Cornwall's proud military heritage remains acknowledged. This book aims to provide some background and insight into a range of places across the county, looking at their roles in times past and what can be found there now. It is categorised according to the six parliamentary constituencies of Cornwall.

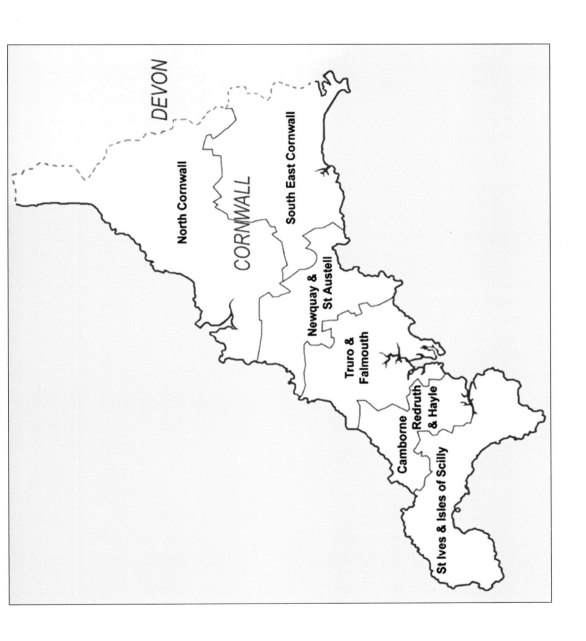

1. St Ives & Isles of Scilly

Battle of Cornwall, 1595

During the Anglo-Spanish war of 1585–1604, a Spanish naval squadron led by Carlos de Amésquita reached the Cornish coast and attacked. They had set sail with the aim of raiding a part of the English coastline to regain the treasure and ships that were captured by the English off Pernambuco four months earlier, and possibly to hold an English port which could then be used as a base for raids and might act as a powerful bargaining tool for any future peace negotiations. With 400 men, they arrived in Mount's Bay on 2 August 1595 and landed on a rocky beach a few hundred yards from Mousehole's harbour. The Spanish fleet then bombarded the defenceless town, resulting in many houses being burned down and three people being killed. From here, they marched half a mile inland to the small village of Paul, where four more people were killed, many taken prisoner, and the town, including its church, was burned down. The following day, the fleet moved into Mount's Bay itself, keeping quite a distance from St Michael's Mount, and torched Newlyn before advancing on Penzance. As the Spanish came ashore, they were attacked by a local

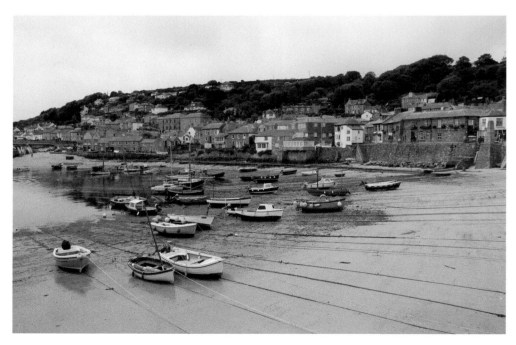

The now tranquil harbour at Mousehole was the first village to be ransacked by the Spanish on 2 August 1595. (Author's collection)

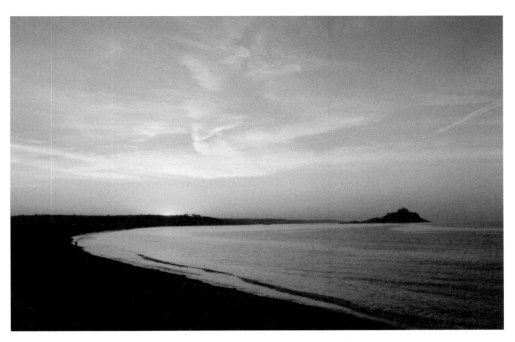

Sunrise over Mount's Bay. (Courtesy of Jim Champion CC BY-SA 2.0.)

militia of 500 men, led by Francis Godolphin. As the ships fired shots into the defenders, the Spanish outflanked them, leading the militia to panic and flee. It is said that only Godolphin and twelve of his soldiers stood to offer resistance, but it was futile against such numbers. In total, 400 houses were destroyed and three goods ships, yet to be unloaded, were sunk. At the end of the raid, a traditional Catholic mass was held in a field on the outskirts of Penzance, with the Spanish commander promising to build a Catholic church on the site once England had been conquered. On August 4, the prisoners were released and the Spanish set sail. It is said to be the only time during the war that the Spanish managed to capture any English towns. Apparently, there was a planned invasion against Cornwall in 1597, but this did not materialise due to a storm in the English Channel.

Cornish Rebellion, 1497

A proud Celtic community, there was an uprising amongst the people of Cornwall in 1497, which later became known as the Cornish Rebellion. Tin miners were angered that previous tax rights, granted by Edward I of England to the Cornish Stannary Parliament, were being overturned by King Henry VII as he looked to raise money for a campaign against Scotland.

It began in the parish of St Keverne on the Lizard peninsula, with Michael Joseph (a blacksmith) and Thomas Flamank (a lawyer of Bodmin) inciting many of the people of Cornwall into armed revolt against the King.

With an army of 15,000 (which included two Cornish MPs) they set off for Devon, collecting supplies and support as they went, before continuing through Taunton and

Wells, where they were joined by James Touchet, the 7th Baron Audley. From here, they passed through Bristol, Winchester, Salisbury and Kent (where they had hoped to gain further support but failed) before arriving at Guildford on 13 June 1497. Shocked by the speed and size of this 'Cornish army', King Henry VII recalled the army of 8,000 men he assembled ready for Scotland, moved his royal family to the Tower of London for safety, and then sent out a force of 500 mounted spearmen who clashed with the Cornish at 'Gill Down' outside Guildford on Wednesday 14 June 1497.

The untrained army left Guildford and moved to Blackheath, where they set up camp overlooking the Thames and city of London from the hill. Overnight, some of the Cornish deserted, leaving only around 10,000 men left for The Battle of Deptford Bridge (also known as Battle of Blackheath). On 17 June 1497, 25,000 of the King's men moved adjacent to the River Ravensbourne and attacked. Severely outnumbered and lacking any supporting cavalry or artillery, the Cornish had placed archers on the bridge at Deptford Strand, which held the royal attack. However, in keeping most of their force back and failing to provide support at this bridge bottleneck, the Cornish missed an opportunity

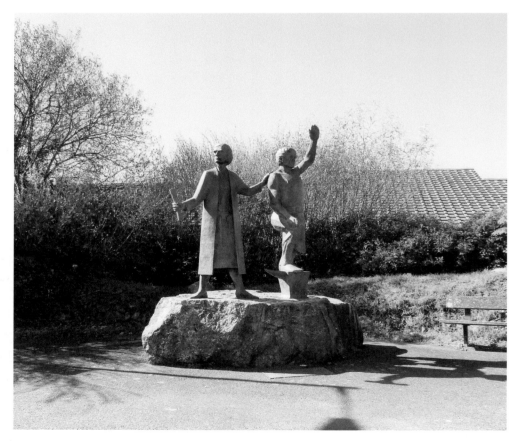

A statue at St Keverne commemorates the two leaders of the Cornish Rebellion of 1497. (Author's collection)

to keep distance between them and the other army that was thrice their size. As one royal division attacked across the bridge and two others outflanked them, the poorly armed and inexperienced Cornish army were slaughtered, leading Michael Joseph to give the order to surrender. He fled to Greenwich before being captured and was hanged, drawn and quartered, along with Thomas Flamank, and their heads were displayed on pikes on London Bridge.

It is estimated that as many as 2,000 were killed in the fight, with those rebels who escaped making their way home as quickly as they could. Cornish estates were quickly seized and handed to more loyal subjects and in the coming years, severe tax penalties were levied against the county, leaving many of its inhabitants living as paupers.

Chûn Castle

On the outskirts of Penzance lies the ruined remains of Chûn Castle, a large Iron Age hill fort that was built around 2,500 years ago. Not much seems to be known about it, but it is believed that the fort fell into disuse around the first century AD, but it may then have been reoccupied – possibly to protect the nearby tin and copper mines (such as Geevor Tin Mine) – until the sixth century. The fort had a ditch, as well as inner and outer defensive walls, and is likely to have been a prominent military position as it overlooks many miles of ocean to the north, and the only land route to the West Penwith peninsula in the south.

The once 20-foot-high walls are now nothing more than rubble thanks to the stone being taken and used for buildings in Penzance and Madron in the nineteenth century.

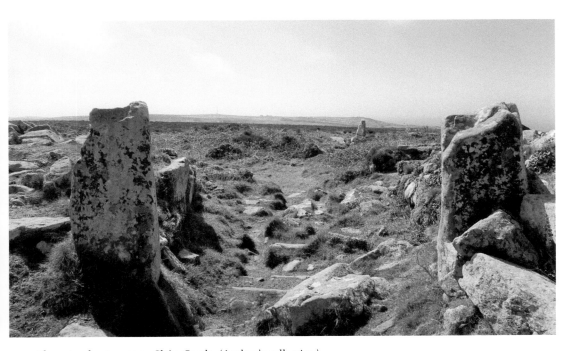

The ruined entrance to Chûn Castle. (Author's collection)

Excavated many times in the early twentieth century, shards of pottery have been discovered, along with leftover iron and tin, near the still existent well.

RNAS Culdrose

One of the largest helicopter bases in Europe, Royal Naval Air Station (RNAS) Culdrose, also known as HMS Seahawk, near Helston, began its life just after the end of the Second World War in 1947. With planning beginning in 1942, it was originally designed to be a wartime airfield, but instead became a base for trials for the Navy's first jets, training for the airborne early warning crews and as a storage base for carrier-based aircrafts.

Over the years, Culdrose has shifted its focus to helicopters, and its main role is serving the Fleet Air Arm's front-line AgustaWestland AW101 Merlin helicopter squadrons. There have been, and continue to be, several different squadrons based at Culdrose, including those associated with anti-submarine warfare, maintenance and training. One of the most notable is 771 Naval Air Squadron, once responsible for search and rescue in Cornwall, the Isles of Scilly and the English Channel. Although they stood down in 2016,

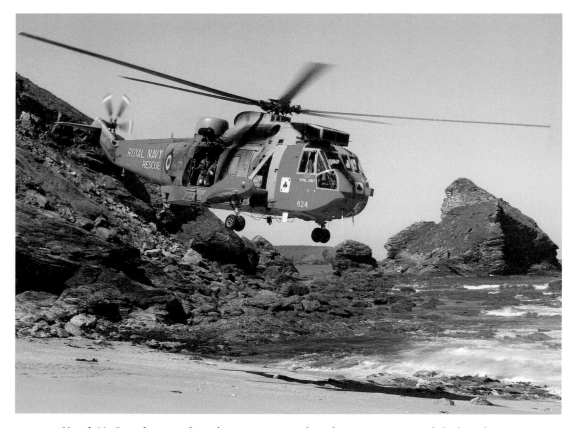

771 Naval Air Squadron conducted over 9,000 search and rescue missions whilst based at RNAS Culdrose. Here pictured on an exercise. (Courtesy of Open Government Licence 3.0.)

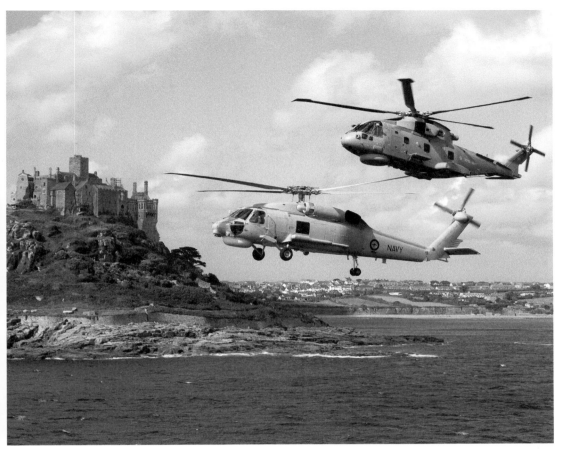

A Merlin HM Mk1 helicopter based at RNAS Culdrose, with a Seahawk from the Australian Navy, flying over St Michael's Mount. (Courtesy of Open Government Licence 3.0.)

it is estimated that they were responsible for saving over 15,000 lives around the 230-mile area they covered. Currently, squadrons based at Culdrose fly the Hawk T1, Avenger T1 and Merlin HM2.

RAF Drytree

RAF Drytree was one of many Chain Home radar stations built the length and breadth of the country in 1940, during the Second World War. Constructed on the Goonhilly Downs, on the Lizard peninsula, this early warning station was used for detecting enemy aircraft approaching South Cornwall and the Western Approaches. The existence of the site was only officially revealed after the war, and much of the station was destroyed in the 1960s (including its original four transmitter masts and two receiver masts) to make way for the Goonhilly Satellite Earth Station. Only a few brick buildings remain now, most of which are located on a nature reserve.

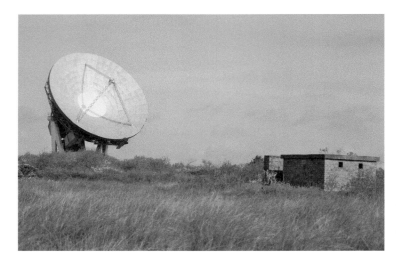

Some of the remains of RAF Drytree, with one of the dishes from Goonhilly Satellite Earth Station in the background. (Author's collection)

Helston Castle

Nothing now exists of Helston Castle, which once sat at the bottom of Coinagehall Street in the town of the same name. It was built for Edmund, 2nd Earl of Cornwall and grandson of King John, in the late thirteenth century. An incredibly wealthy man, he controlled most of Cornwall's divisions. Helston was granted a municipal charter by King John in 1201; the castle overlooked the river valley, which at the time was accessible from the sea. Very little is known about the size and shape of the castle, with some suggesting it was just a fortified manor house. By 1478, William Worcester recorded that the castle was in ruins, and only fifty years later, John Leland recorded that there were only traces of the castle remaining even then.

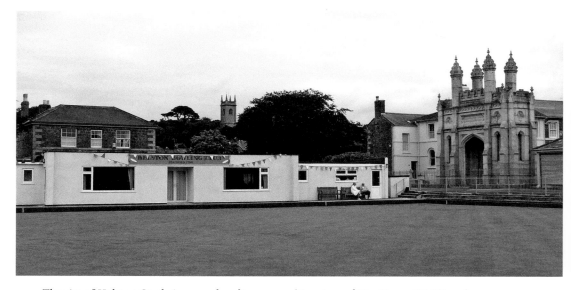

The site of Helston Castle is now a bowling green. (Courtesy of Tim Green CC BY 2.0.)

Isles of Scilly

Twenty-five miles off the southwestern tip of mainland Cornwall lies the picturesque Isles of Scilly. Due to their location, their history is extensive. They were captured by the Parliamentarians during the English Civil War, but the garrison they installed there mutinied and returned the islands to the Royalist governor at the time, Sir John Grenville. As the Parliamentarians took Cornwall and the west of England, the Royalist Navy was forced to retreat to the Isles of Scilly. With such a force now under his control, he used the islands as a base for privateering raids on Commonwealth and Dutch shipping, who had allied themselves to the Parliamentarians, confident they would win the war. However, they suffered heavy losses, leading the Dutch admiral Maarten Tromp to ask for compensation and, as he didn't receive any, and with most of England in Parliamentarian hands, war was declared specifically upon the Isles of Scilly. Soon after this declaration, in June 1651, Robert Blake and his Parliamentarian forces made the Royalists surrender, and the Dutch fleet left. No shot was ever fired and, interestingly, peace was never officially declared.

In one of the nation's more interesting footnotes, this alleged state of war between the Isles and the Netherlands has been referred to as the Three Hundred and Thirty-Five Years' War, as it wasn't until 17 April 1986, exactly 335 years after the supposed declaration

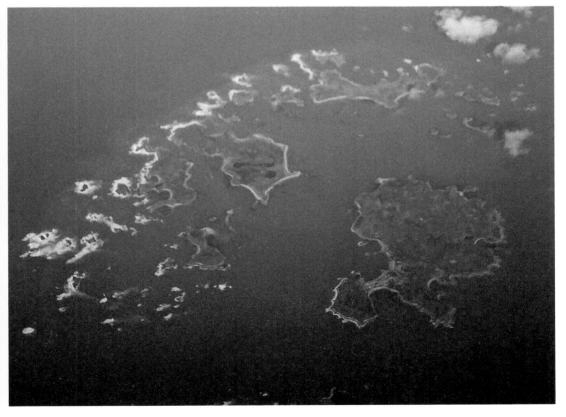

The Isles of Scilly. (Courtesy of Mike Knell CC BY-SA 2.0.)

The original slipway of RNAS Tresco can still be seen at New Grimsby. (Author's collection)

of war happened, that peace was officially declared by the Dutch ambassador to the UK Jonkheer Rein Huydecoper on an official visit to the islands.

The First World War saw a temporary naval submarine station created at St Mary's using admiralty tugs and armed trawlers, creating a protective base for British submarines trying to counter German ships. Of course, at this time, German submarines provided a significant danger to British shipping. One of the best ways to locate them was by using aircraft and airships as spotters, as they could see them from miles away and then guide and direct attacks. As a result, an airship station was built at Holy Vale on St Mary's, although this was soon abandoned, and a flying boat and seaplane base was to be constructed in 1917 at Portmellon on Tresco. However, the bay here was too exposed, so the base moved to New Grimsby on Tresco, known as RNAS Tresco, which had a slipway, hangars, offices and quarters for No. 243 Squadron RAF. From February 1917 to May 1919, these aircraft patrolled the Western Approaches and provided an escort for convoys, sighting thirteen U-boats and attacking nine of them. There are no remains of the first two sites, but at New Grimsby, the ramp and impressions of a few buildings are still there.

During the Second World War, a Radio Direction Finding Station (RDF) was built at Peninnis Head, the southernmost point of St Mary's, as part of the country's efforts to protect itself. On 21 August 1940, an enemy aircraft bombed the RDF in what was the first hostile action on the islands. While this attack was unsuccessful, the RDF was

destroyed just over a year later. During this conflict, Star Castle was used as a military headquarters, and with two independent companies on the islands, two destroyers stationed themselves at St Mary's to provide air cover before two Bofors anti-aircraft guns were brought over from the mainland. Pillboxes were built, beaches were wired, and in May 1941, six Hawker Hurricanes landed at the small aerodrome to provide more resilient air cover. Off the north coast of St Mary's, at Crow Sound, floating targets were moored as a bombing range and, on what is now known as Normandy Down near Deep Point, a huge concrete directional arrow pointing towards an old target remains.

Isles of Scilly – Cromwell's Castle

In the aftermath of the Parliamentary invasion and capture of the Isles of Scilly in 1651 during the English Civil War, General Robert Blake of the Parliamentarian forces built an artillery fort on Tresco. Constructed in 1651–52 and named after Oliver Cromwell, the Parliamentarian leader, it was built on the western side of the harbour to protect the deep-water channel leading to New Grimsby harbour.

This three-storey circular tower, with 4-metre-thick walls and standing at a height of 15 metres, was built on top of a small sixteenth-century blockhouse that was originally built as part of the nearby King Charles's Castle, which was blown up by Royalist forces prior to Blake taking the islands. Stone from the ruins was used for this new structure, which had six-gun ports that provided a good range of fire between the islands of

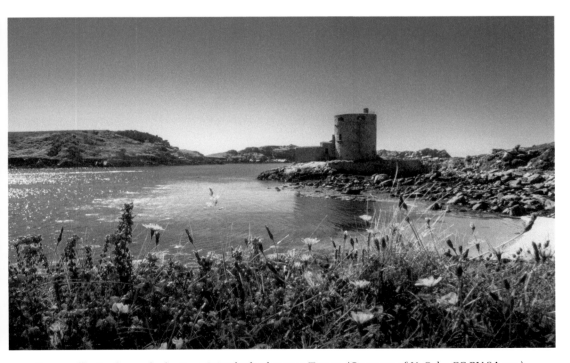

Cromwell's Castle overlooks New Grimsby harbour on Tresco. (Courtesy of N. Osha CC BY-SA 2.0.)

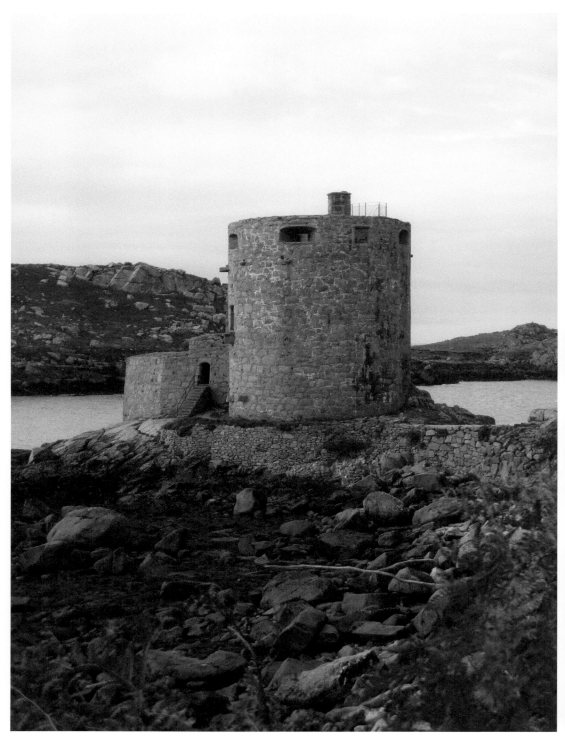

Built in 1651 by Robert Blake after Parliamentarian forces took control of the islands.

Tresco and Bryher. In 1739, a gun platform was added, and Cromwell's Castle was re-armed with 9-pounder cannons and the tower roof with 4-pounder guns. Despite offering protection to the harbour, the castle was never really used and soon fell into disrepair. This Grade II listed building is now looked after by English Heritage, with the roof still accessible.

Isles of Scilly – Harry's Walls

In 1551, construction of an artillery fort overlooking the harbour of Hugh Town was started by the government of Edward VI to defend the island of St Mary's from a possible French attack. The plans showed a square fortification with four angular 'arrow-head' bastions in the corners, but work was slow. By 1554, only two light artillery guns were installed along with an unsuccessful attempt to create a garrison of 150 men on the island; because of this lack of manpower, combined with a shortage of funds and the eventual passing of the invasion threat, the fort was never completed. Although proposals were discussed to complete the work in 1591, new defences were instead constructed at Star Castle, with only the south-west side partially constructed. The ruined south-western side of the fort remains, managed by English Heritage, with two bastions just over 2 metres high, and a 27-metre-long curtain wall that sits just under 2 metres high.

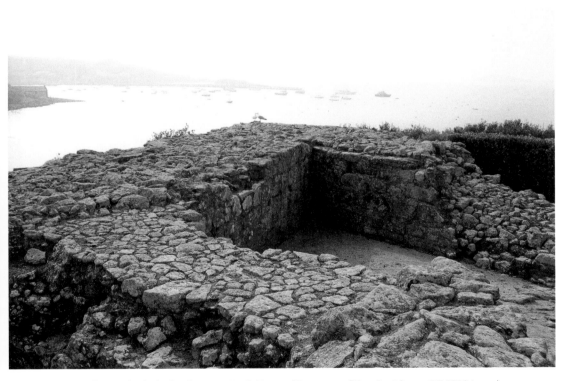

Harry's Walls overlook the harbour at Hugh Town. (Courtesy of Ben Smitheon CC BY-SA 2.0.)

Isles of Scilly – King Charles's Castle

In the sixteenth century, tensions with France were high, leading to war in 1538 and the coasts of England being lined with defences such as artillery forts that were equipped to defend against the longer-range cannons. As part of this programme of work, between 1548 and 1551, King Charles's Castle was built on the high ground of Castle Down to protect New Grimsby harbour on Tresco. Holding a battery of five guns on the west side overlooking the sea and buildings to house a garrison, it would have aimed to prevent enemy vessels from entering the harbour; however, by 1552, all construction on the Isles of Scilly was halted due to a lack of funds, and it then became evident that this castle had been built in a poor location.

Standing 40 metres above sea level meant its guns could only fire at enemy ships in the harbour by being angled downwards, resulting in the cannonballs simply falling out of the muzzles. By 1554, a small blockhouse had been built just above sea level, beneath the castle (later to be built upon for Cromwell's Castle), to help compensate for these issues, but building never resumed and the new Star Castle was constructed on the island of St Mary's between 1593 and 1594, and this became the main defensive site for the islands.

During the English Civil War, Tresco was a base for Royalist privateers, and Parliamentarian Robert Blake set about invading the island in April 1651. The Royalist commander of the castle at this time, William Edgecumbe, retreated from the castle and

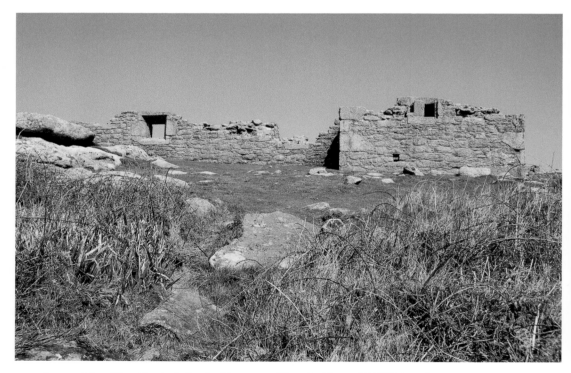

Approaching King Charles's Castle. (Courtesy of Ben Smitheon CC BY-SA 2.0.)

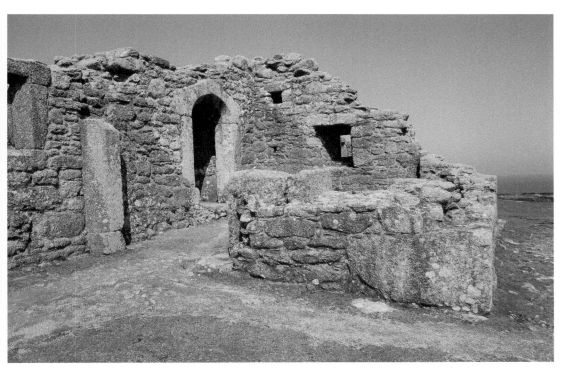

The old entrance gives a tantalising idea of what the castle might have looked like when first built. (Courtesy of Ben Smitheon CC BY-SA 2.0.)

the defenders blew up part of the site as they left, leaving the remains to the Parliamentary commander Colonel George Fleetwood.

It is apparent now that stonework from the ruins of King Charles's Castle was taken by the Parliamentarians and reused in the construction of Cromwell's Castle, using the blockhouse as its foundations. Since then, the ruins have remained just that, with the Grade II listed building now managed by English Heritage and open to the public.

Isles of Scilly – Star Castle & the Garrison

Built in 1593, Star Castle was constructed following the aftermath of the Spanish Armada in 1588 due to the continued threat posed to the Isles of Scilly by the notorious Spanish fleet. With the other castles poorly located on Tresco, a new site was needed, leading to a prominent headland jutting out on the west side of St Mary's known as The Hugh, considered the perfect place for overlooking Hugh Town and its harbour.

As a lookout for any intruder ships that might be heading to England, Star Castle was built in the shape of an eight-pointed star and was the focal point of this new defensive position known as the Garrison. On the landward side, a curtain wall was built across the headland and contained a fortified entrance and four bastions.

During the English Civil War, the Royalists on the Isles of Scilly initially surrendered to the Parliamentarians, but two years later, a revolt led to the Garrison becoming a Royalist

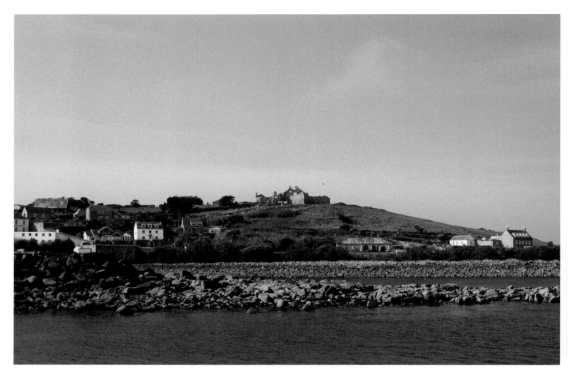

Star Castle and the Garrison dominate the headland overlooking Hugh Town. (Courtesy of Ben Smitheon CC BY-SA 2.0.)

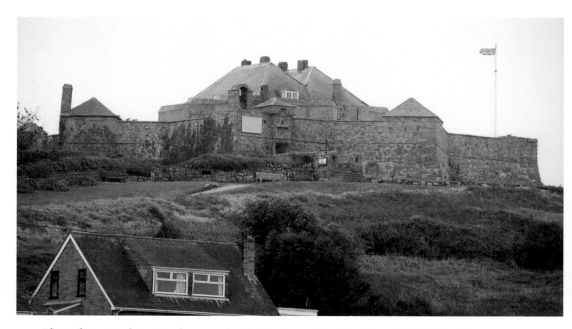

The eight-pointed Star Castle, now a hotel. (Courtesy of Ben Smitheon CC BY-SA 2.0.)

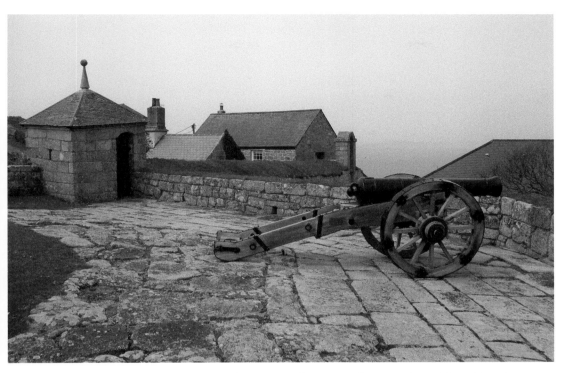

Cannons and defensive positions cover the Garrison. (Courtesy of Ben Smitheon CC BY-SA 2.0.)

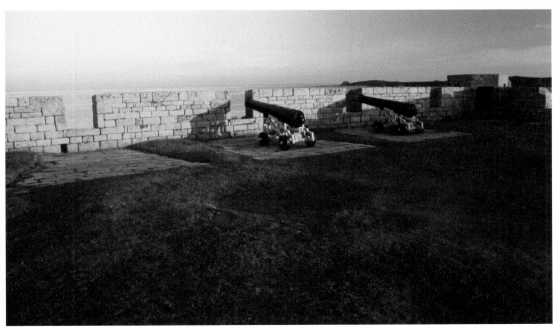

A view from Woolpack Battery. (Courtesy of Ben Smitheon CC BY-SA 2.0.)

stronghold and a base for up to 800 men, until they were eventually surrounded and surrendered in 1651. With an invasion by the French or Spanish still looming during the seventeenth and early-eighteenth centuries, the curtain wall was extended until it surrounded the whole of the headland, with strategically placed gun batteries at regular intervals around the outer wall, allowing covering fire at all angles, from sea or land.

Workshops, stores and houses were built, and with additional strengthening of the headland taking place between 1898 and 1906, the significant Steval Point and Woolpack batteries combined with the Greystones Barracks were added to this impressive defensive position.

The Garrison was used in both the first and second world wars due to its prominent position in the Atlantic where it was an important signal station, containing over one thousand servicemen here alone. Today, Star Castle is a hotel, with the fortifications of the Garrison being very well preserved and managed by English Heritage, allowing visitors to walk most of the walls and explore some of the batteries.

Maen Castle

Close to Land's End, at the very tip of Cornwall, lies the site of what is believed to be Maen Castle – an Iron Age 'cliff castle'. Excavations at this site over seventy years ago uncovered evidence of Iron Age pottery, as well as the remains of what was a stone defence wall built across the neck of the headland. With near vertical cliffs on two sides, and a steep slope on the third, it is obvious why this site was chosen by our Cornish ancestors as a defensive base.

The spectacular view from the site of Maen Castle. (Courtesy of Jim Champion CC BY-SA 2.0.)

RNAS Mullion

In response to the significant threat caused by German U-boats to merchant shipping and the Royal Navy during the First World War, RNAS Mullion was commissioned in 1916. Initially called Lizard Airship Station, over 300 acres were turned over to a sprawling complex of accommodation buildings, gas storage tanks and two gigantic airship hangars, which would allow airships to go on anti-U-boat patrols off the Cornish coast and in the South West for the remainder of the war. The Coastal Class airship had a crew of five, all armed with machine guns and depth charges; as well as performing reconnaissance and patrolling, they also went mine-hunting and provided convoy escort duties. One such airship, the C-9, had a total of 3,720 flying hours and covered a staggering 68,200 miles, with one confirmed and three probable U-boat kills. The station closed in 1919, and the building was promptly torn down and the land returned to the farmers. Today, hardly anything remains of RNAS Mullion, with large wind turbines now standing on the site.

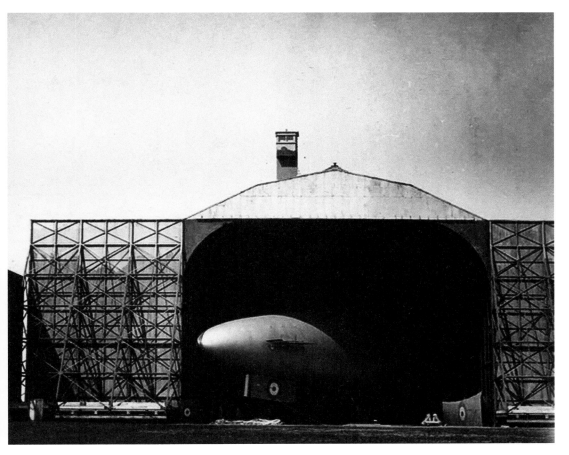

A stunning photograph of one of the hangars and an airship at RNAS Mullion.

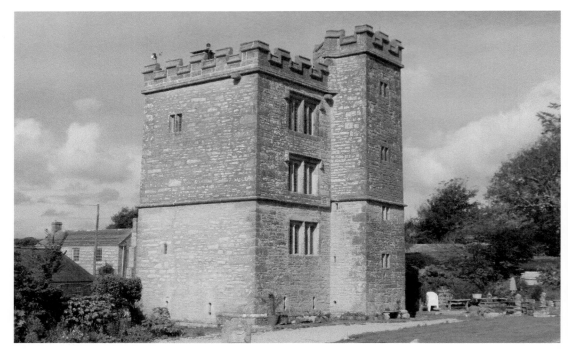

The reportedly haunted Pengersick Castle at Praa Sands. (Author's collection)

Pengersick Castle

Built in 1510 by William Worth, Pengersick Castle is more of a fortified manor house located a few hundred metres from the beach in the village of Praa Sands. With the Tower House still standing strong today, it is said to have been renovated around 1530 using the proceeds of the wreck of a valuable Portuguese ship. The castle is supposedly haunted by the ghost of John Milliton, former High Sheriff of Cornwall and Governor of Saint Michael's Mount in 1547. The castle is now used as a events centre, with tours available.

Penzance

As the most westerly major town in Cornwall, with the English Channel and Atlantic Ocean within reach, it is not surprising that Penzance has an important harbour. Located in the shelter of Mount's Bay, the town was often raided by Turkish pirates in medieval times, and on 3 August 1595, in what is known as The Battle of Cornwall, the town was attacked by a Spanish fleet. Despite having a local militia of 500 men, the Spanish outflanked them, causing all but twelve of the defenders to stand their ground. 400 houses were destroyed and three goods ships in the docks, yet to be unloaded, were sunk, as the Spanish managed to set off with their boats full.

During the English Civil War, Penzance was attacked, and subsequently taken by the Parliamentarian forces of Sir Thomas Fairfax, although the town itself was relatively unscathed. In 1740, with the continued threat of French and Spanish invasion, a battery was built on a granite platform situated on a rocky outcrop overlooking Mount's Bay. With

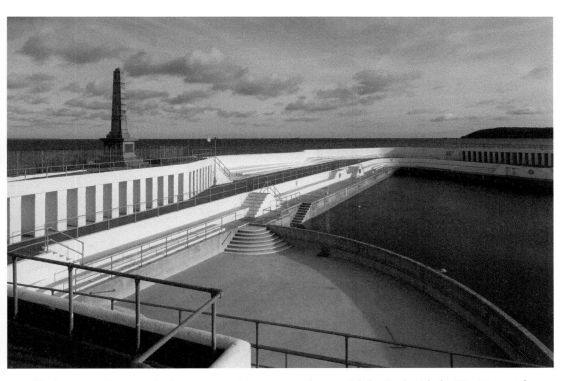

The battery at Penzance harbour was used to construct the 1935 Jubilee Pool, with the War Memorial still in situ. (Courtesy of Tom Parnell CC BY-SA 2.0.)

the walls designed to provide protection against the sea, five cannons were installed, and throughout the eighteenth century, it was manned by a volunteer company, providing Penzance harbour with the protection it needed throughout the Napoleonic Wars.

Artillery was in situ for the First World War, defending the harbour and its boats from a potential U-boat attack, and in 1922, the town installed a war memorial here to the 207 local men who lost their lives. The dry dock and workshops of the harbour were used by the Royal Navy throughout the interwar years, and during the Second World War, 14-inch Mk VII guns were placed at the battery, with nearby Bofors guns and searchlights providing additional protection for shipping and the harbour. With Nazi Germany's desires to invade England, it is no surprise that the town and its harbour suffered during the Blitz years, 1940 to 1942. A total of 16 people were killed, 48 houses completely destroyed and a further 157 seriously damaged.

Porthcurno

A small footnote in the grand scheme of things, Porthcurno is home to PK Porthcurno: Museum of Global Communications, once the world's largest submarine telegraph station. Founded in 1870 with a line from Great Britain to India, further cables were laid to Newfoundland, France, Spain and Gibraltar – essentially becoming the communication gateway to the Commonwealth. This essential facility was thought to be significantly

Cables connecting Britain to the rest of world lay under Porthcurno Beach. (Courtesy of James Burke CC BY 2.0.)

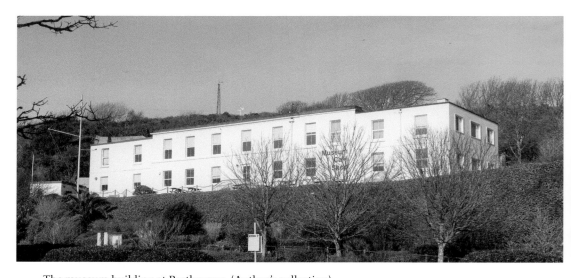

The museum building at Porthcurno. (Author's collection)

vulnerable to attack during the Second World War, so in 1941, miners were employed to cut tunnels into the solid granite of the valley's hillside to house the telegraphy equipment, thus protecting these vital lines of communication to the rest of the world.

RAF Predannack

Built in 1941, RAF Predannack was urgently constructed on the Lizard peninsula as a satellite airfield for RAF Portreath, following the capitulation of France in June 1940,

which resulted in the urgent need to protect the country from the serious threat of German invasion. No. 247 Squadron arrived with Hawker Hurricanes that were initially tasked with the night defence of the South West's towns and ports. Accommodation for the staff was situated across the wider area, with officers billeted in the Mullion Cove and Polurrian hotels. No. 600 Squadron arrived with Bristol Beaufighters that were equipped with Airborne Interception radar. Using the Chain Home radar stations, they were able to successfully defend much of the airspace in and around Cornwall, as well as the airfield itself, which was attacked several times.

As the tide of war turned, and the Bomber Offensive against mainland Europe began, RAF Predannack became a good location for emergency landings for returning aircraft. As a result of this, the runways were extended in 1943 to cater to larger aircraft, and this meant that the airfield became a staging and departure point for aircraft en route to the North African campaign. By 1944, around 3,600 crew and support staff worked here, and as part of the invasion convoy for Operation Overlord (D-Day) assembled at Falmouth, Spitfires from No.1 and No. 165 Squadrons at Predannack provided crucial aerial cover. At the latter end of the Second World War, Liberators took part in regular anti-submarine patrols over the Bay of Biscay, the English Channel and the Atlantic. In 1946, the airfield closed to operational tasks, becoming a care, maintenance and training facility for the nearby RNAS Culdrose.

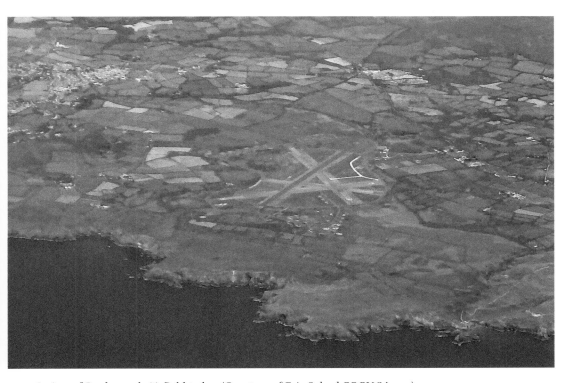

A view of Predannack Airfield today. (Courtesy of Eric Salard CC BY-SA 2.0.)

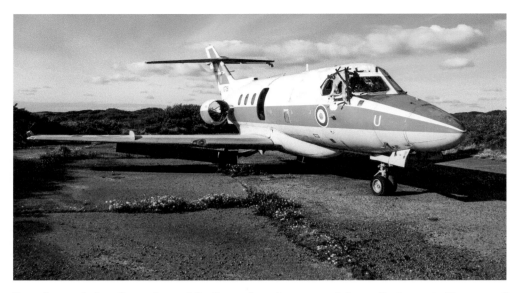

One of several aircraft wrecks used for fire and crash rescue training at Predannack. (Courtesy of Steve Lynes CC BY 2.0.)

St Michael's Mount

Considered one of the most iconic places in Cornwall and once the site of a monastery, St Michael's Mount has a strong military history. Linked to the town of Marazion by a man-made causeway, this tidal island in Mount's Bay has been used as a stronghold and symbol of power by many, despite its humble beginnings. The old monastery, believed to date from the eighth century onwards, was gifted to the Benedictine order of Mont Saint-Michel by Edward the Confessor. It welcomed pilgrims for centuries, until Sir Henry de la Pomeroy captured the Mount in 1193 on behalf of Prince John – the first of many to seize and hold this imposing place.

A number of religious buildings were constructed on the 57-acre site, including an original priory church, destroyed by an earthquake in 1275, and a castle. In 1424, it was given to the Abbess and Convent of Syon at Isleworth, Middlesex, and in September 1473 the 13th Earl of Oxford, John de Vere, took over the island and held it during a staggering twenty-three-week siege against 6,000 of King Edward IV's troops. A combination of bloodshed and the cold winter months caused many of his men to desert the battle, and he eventually surrendered in February 1474. Just over twenty years later, in 1497, Perkin Warbeck (imposter and pretender to the English throne) briefly occupied the Mount just a few months after the Cornish Rebellion of the same year, and in 1549, Sir Humphrey Arundell, Governor of St Michael's Mount, led the Prayer Book Rebellion from here.

During the English Civil War, Sir Arthur Bassett, held St Michael's Mount for the Royalists against the Parliamentarian forces, until they finally captured it in July 1646. Life on the Mount calmed down after this, with the notable exception of pillboxes being built on the island during the Second World War in 1940. Although the castle and chapel have been the home of the St Aubyn family since approximately 1650, St Michael's Mount is now managed by the National Trust.

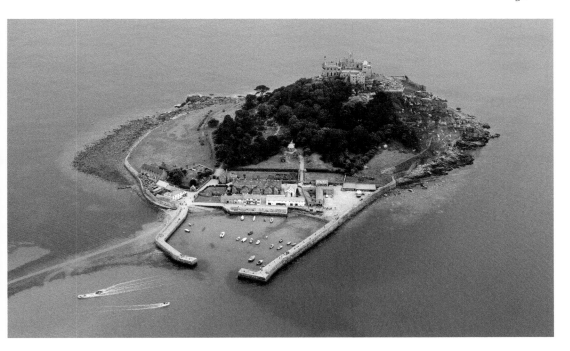

Above: A stunning aerial view of St Michael's Mount. (Courtesy of John Fielding CC BY 2.0.)

Right: View of the castle and its huge walls. (Courtesy of John Fielding CC BY 2.0.)

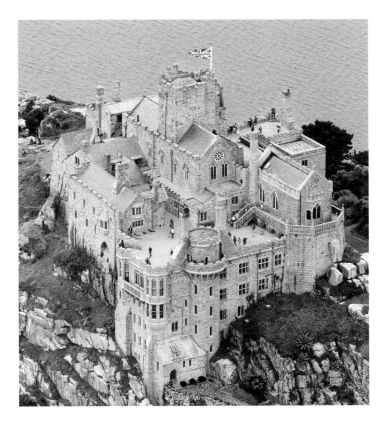

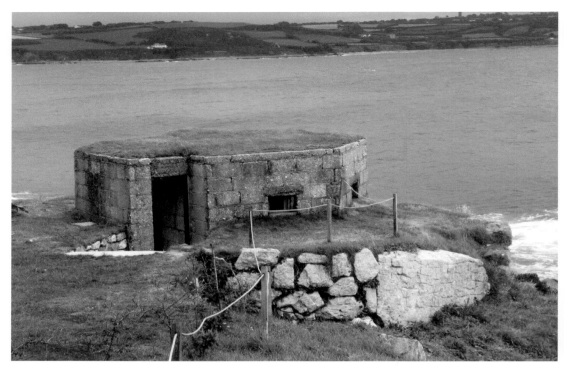

A Second World War pillbox on the Mount. (Courtesy of Jim Champion CC BY-SA 2.0.)

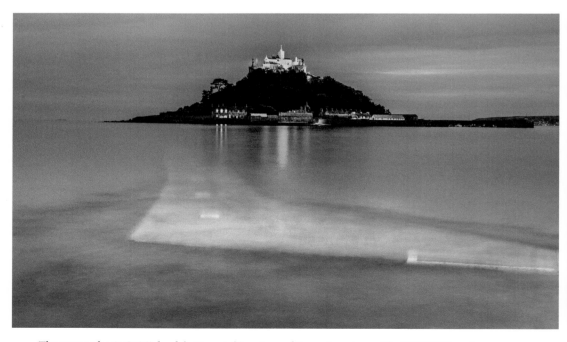

The atmospheric St Michaels's Mount. (Courtesy of Tony Armstrong-Sly CC BY-ND 2.0.)

Treryn Dinas

On the Penwith peninsula, between Penberth Cove and Porthcurno, lies the National Trust-owned scheduled monument Treryn Dinas. This was an Iron Age hill fort that was chosen for its defensive qualities: three of its sides slope steeply into the sea, leaving just one landward side where defensive earthworks were constructed. Thought had clearly gone into this site, as across the narrowest part of the headland was a 2-metre-high rampart, and beyond this the entrance was set into a massive 6-metre-high rampart. The South West Coast Path runs alongside this outer rampart, and these earthworks are now all that remain of what would have been a very impressive hill fort.

The incredible location of Treryn Dinas, an Iron Age hill fort. (Courtesy of Jim Champion CC BY-SA 2.0.)

2. Camborne, Redruth & Hayle

Carn Brea Castle

A castle by name only, Carn Brea was originally built as a chapel in 1379, but then remodelled as a hunting lodge in the eighteenth century by the Basset family. Irregular in its layout, it has four turrets and is built onto a huge stone outcrop; these uncut boulders give it quite a distinctive appearance. Considered by many to be a folly, it has a steep drop on one side and was used as a beacon for ships in 1898, with a light shining from its north-facing window.

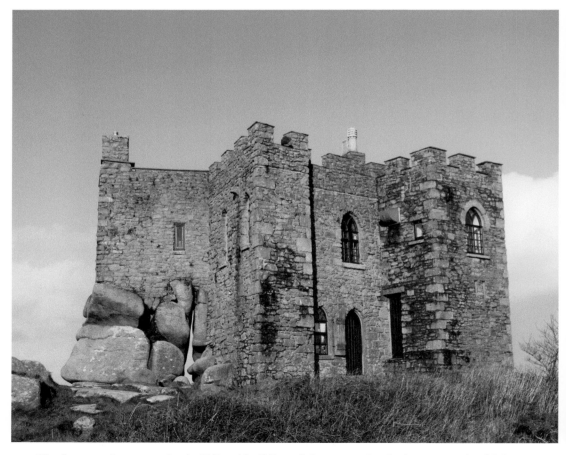

The fourteenth-century Grade II listed building of Carn Brea Castle. (Courtesy of Ashley Van Haeften CC BY 2.0.)

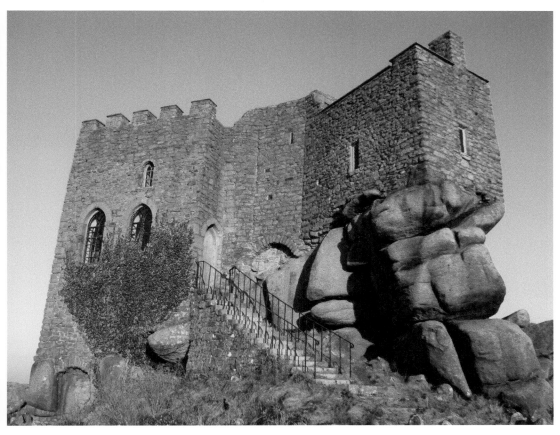

The castle sits precariously on top of a rocky outcrop. (Courtesy of Philip Male CC BY 2.0.)

RRH Portreath

Originally known as RAF Portreath, and part of the RAF St Mawgan site, the station was built in 1940 in response to the threat of invasion in the Second World War on Nancekuke Common, around 1 mile from the village of Portreath. Opening in March 1941, it was an RAF Fighter Command station until October 1941, when it took on a similar role to RAF Predannack, as a stop-over for aircraft heading to North Africa and the Middle East. As D-Day approached, it was a stopover for USAAF and RCAF units heading to Europe and finished the war as an RAF Coastal Command station, participating in U-boat patrols in the Atlantic and Western Approaches.

After the war, it became an outstation of Chemical Defence Establishment (CODE) Porton Down, manufacturing the toxic nerve agent sarin, and being used as a storage facility for stockpiling the country's chemical defences during the Cold War right up until 1980, when a majority of the associated buildings were torn down.

In October 1980, the RAF reopened the site as a Control and Reporting Post (CRP) for UK Air Surveillance, with new telecommunications and mobile radar systems being installed by the mid-1980s. Still in operation today, it is known as Remote Radar Head

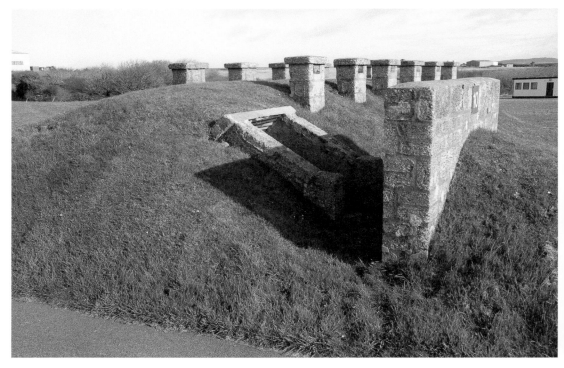

Parts of the Second World War airfield remain. (Courtesy of Richard E Flagg)

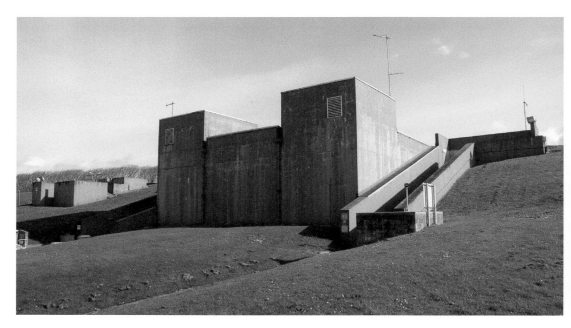

A control and reporting post from the Cold War. (Courtesy of Richard E Flagg)

(RRH) Portreath, and the site has Type 102 Air Defence Radar, housed in a fibreglass protective dome that provides long-range coverage of the Southwest Approaches to the United Kingdom.

Trebah

It's hard to believe, but it was from the secluded Polgwidden Cove, at the foot of the beautiful Trebah Garden, that thousands of American troops boarded their ships for the Normandy landings. In 1944, nearby Budock Vean Hotel was requisitioned while the beach at Trebah was concreted, along with the boathouse, to allow better access for tanks.

These glorious gardens were once used as an ammunition store, and in June 1944 a regiment of around 7,500 men of the 29th US Infantry Division, along with their tanks, guns and transport, embarked from Trebah Beach in ten 150-foot, flat-bottomed LST landing crafts. Their destination was Omaha Beach, which had the highest number of casualties on D-day, and a memorial to their bravery sits at the bottom of Trebah Garden.

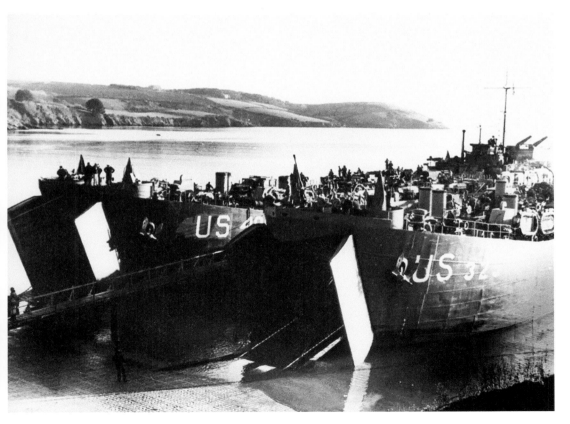

US Landing Craft at Trebah Garden.

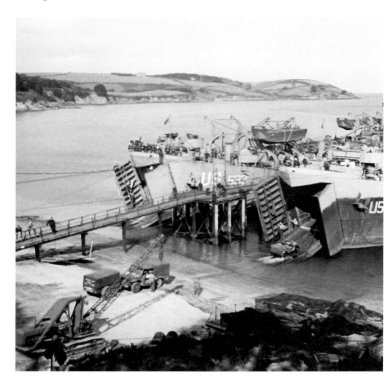

Left: Troops leaving here would find themselves on Omaha Beach on D-Day.

Below: Some of the concrete remains at Polgwidden Cove today. (Courtesy of Tim Green CC BY 2.0.)

3. Truro & Falmouth

Falmouth

The town of Falmouth sprung up around Pendennis Castle in the late sixteenth to the early seventeenth century. As the name suggests, it is located at the mouth of the River Fal, and it is not surprising that a harbour and port was built over the centuries considering its formidable defensive position. Formally created by Sir John Killigrew in 1613, as the harbour grew, so did the castle's defences, and during the English Civil War (1642–51) Royalists fought desperately to hold on to the area, and it became the penultimate fort to surrender to the Parliamentary Army. The strategic military importance of Falmouth's location – being a large port right at the entrance to the English Channel – meant that two Royal Navy squadrons (five frigates in each) were permanently stationed here, and during the French Revolutionary Wars (1792–1802) battleships and small vessels were constantly docking here.

It is interesting to note that two camps for French prisoners were built at Tregellick and Roscrow around this time. Development began for the Falmouth Docks from 1858, and around the same time, the 1860 Royal Commission on the Defence of the United Kingdom made further defensive improvements to Pendennis Castle due concerns about the strength of the French Navy. The First World War saw 240 men from the town lose their lives, whilst the docks provided a vital base for anti-U-boat activities. During the Second

Falmouth Docks today. (Courtesy of Tim Green CC BY 2.0.)

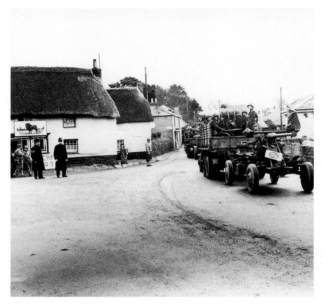

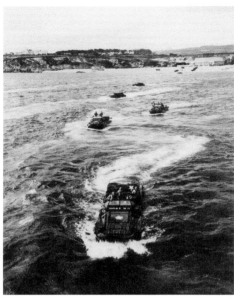

Above left: US troops in and around the area during the Second World War.

Above right: Duwks off the coast of Cornwall in 1944. (Courtesy of US Navy)

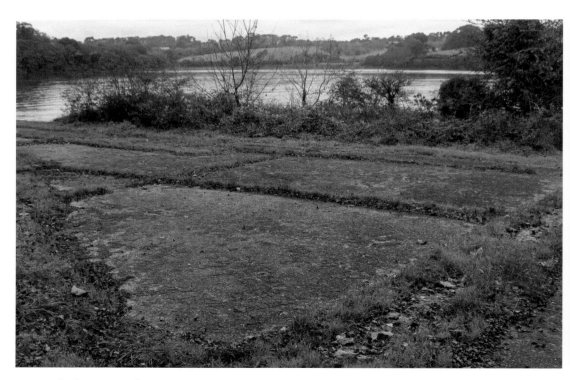

Embarkation port for D-Day at Turnaware Point. (Author's collection)

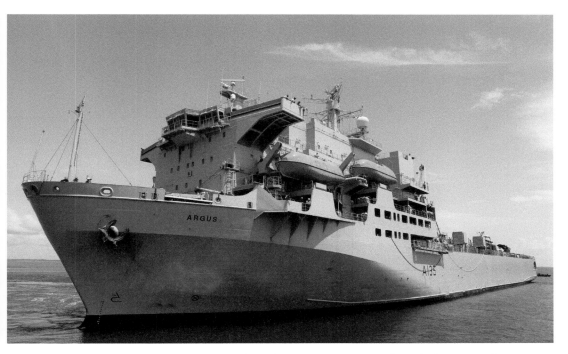

RFA *Argus*, a ship of the Royal Fleet Auxiliary, has its home port at Falmouth. (Courtesy of Open Government Licence 3.0.)

World War, the town was an obvious target for German bombers, and at least thirty-one civilians were killed in the town. To help protect the docks and prevent enemy U-boats entering the harbour, an anti-submarine net was laid from Pendennis to St Mawes, and it was from Falmouth Docks that the 1942 commando raid on Saint-Nazaire was launched. In the build-up to D-Day, Falmouth became an important hub for American troops, and between 1943 and 1944 thousands descended to the town and the nearby area. Falmouth Docks, along with nearby Trebah Garden, Tolverne, and Turnaware Point at Trelissick saw men of the 29th (US) Infantry Division embark on a journey to Omaha Beach in June 1944 – the area was frantic with activity around this time. To this day, the embarkation hards are still visible; they were used for loading the landing craft alongside marshalling areas, buildings and various roads that aided this process. Falmouth is still home to some naval vessels, and the shipyards continue to provide maintenance work.

Pendennis Castle

Built by King Henry VIII in 1540 to help defend Carrick Roads – the estuary of the River Fal – against a possible invasion from France and the Holy Roman Empire, Pendennis Castle is a spectacular defensive position in Falmouth that overlooks the English Channel.

Pendennis and St Mawes Castle were positioned on each side of Carrick Roads to provide an overlapping field of fire across the water. The sixteenth-century circular keep, with its 3-metre-thick walls, was surrounded by a gun platform and could be entered through a

bridge and a forebuilding. This was all expanded at the end of the century to cope with an increased Spanish threat, with a ring of stone ramparts, earthworks and bastions built around the older castle. During the English Civil War, Pendennis was held by the Royalists, with Falmouth harbour providing a vital base for Royalist supplies and shipping raids.

As the Parliamentarians entered Cornwall with a large army, they quickly took most Royalist strongholds, but Pendennis proved different. Defended by around 1,000 soldiers under the command of Sir John Arundell, it held strong for six months. Two Parliamentary colonels led a bombardment of the castle from the land, while a flotilla of ten ships blockaded it by sea, preventing fresh supplies from arriving and ultimately forcing them to surrender in August 1646. By 1660, new fears of a foreign invasion had begun, leading to an additional gun battery being constructed, as well as a new guard barracks and a classic gatehouse.

In the 1730s, the castle was again modernised, the interior redesigned, the ramparts rebuilt, and the castle's guns replaced with 18-pounder cannons. In 1795, the Crown purchased the castle's land from the Killigrew family and reinforced the fortress to, yet again, deal with a fresh threat of invasion. The landward defences were reinforced, and a new gun position called the Half Moon Battery was built just outside the sixteenth-century walls. The end of the Napoleonic Wars in 1815 saw the castle become neglected, before renewed fears of a French invasion in the 1850s saw better artillery installed. In 1902, the 105th Regiment Royal Artillery took over the manning of Pendennis Castle, and during the First World War the castle was reinforced by territorial soldiers as it defended the harbour, as well as being used for training purposes. Twin 6-pounder guns and long-range artillery were installed at the beginning of the Second World War, with zig-zag trenches being dug for protection and a range of new buildings being added to the site.

Falmouth Fire Command, stationed in the sixteenth-century keep, had new radar-controlled, 6-inch Mark XXIV guns in 1943 as the gun batteries at Pendennis were used to defend against German submarines. Decommissioned in 1956, the castle is now open to the public and is a well-maintained and fascinating place, with centuries of fortifications interweaved with each other.

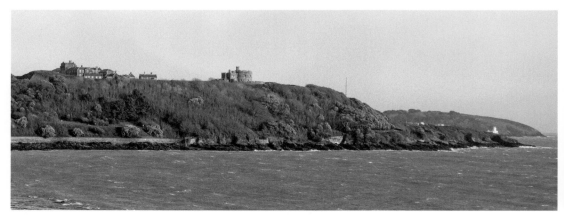

A view of Pendennis Castle sitting atop Pendennis Point, with the twentieth-century artillery barracks on the left and the older sixteenth-century keep on the right. (Courtesy of Tim Green CC BY 2.0.)

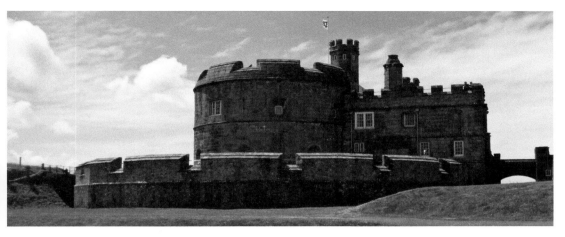

The sixteenth-century keep still stands strong. (Courtesy of Mark AC Photos CC BY-SA 2.0.)

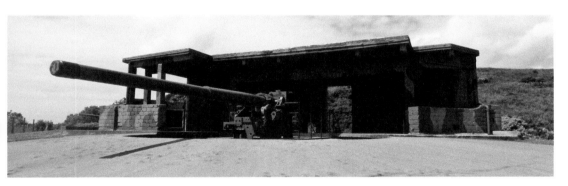

A Second World War gun still in situ in the Half-Moon Battery. (Courtesy of Mark AC Photos CC BY-SA 2.0.)

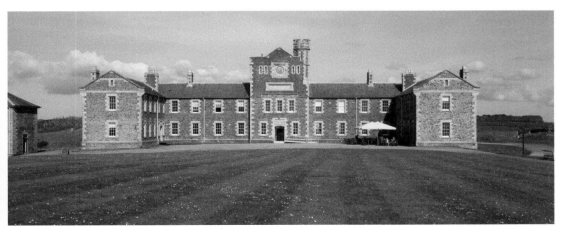

The Royal Artillery Barracks at Pendennis Castle. (Courtesy of Tom Parnell CC BY-SA 2.0.)

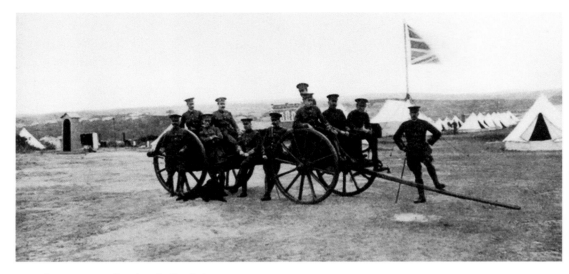

A gun crew at Pendennis Castle in 1914.

RAF Perranporth

Built in 1940, RAF Perranporth was operational from 1941 until the end of the Second World War in 1945. Located on Cligga Head on the north Cornish coast near Perranporth, the 330-acre site was an RAF Supermarine Spitfire base that had twenty-one different squadrons stationed there, providing aerial cover for shipping convoys, support for bombing raids and anti-aircraft defence throughout the conflict. After the war, the airfield was converted to civilian use in the form of Perranporth Airfield, but there are still some bunkers, air-raid shelters and revetments on the site.

Part of Perranporth Airfield today. (Author's collection)

Prayerbook Rebellion, 1549

In 1549, the Book of Common Prayer was introduced and was the final straw for many across Devon and Cornwall. After years of oppression through means of inflation, enclosure of common land and poor economic conditions, the enforcement of the English language led to an explosion of anger and, ultimately, an uprising. It was a range of legislative measures aimed at changing theological practices. An army gathered at the town of Bodmin under the leadership Mayor Henry Bray. Many of the gentry were besieged by the rebels, and a shortage of food forced them to surrender. The Cornish Army marched across the River Tamar into Devon to join with the Devon rebels near Crediton before a series of skirmishes and fights took place, ultimately ending in defeat for the rebels – over 5,500 people lost their lives. Although the rebels had ceased fighting, English and mercenary forces continued to move throughout Devon and Cornwall and execute or kill many of them before the bloodshed officially ceased. Many have identified this as the turning point of the Cornish language and national identity.

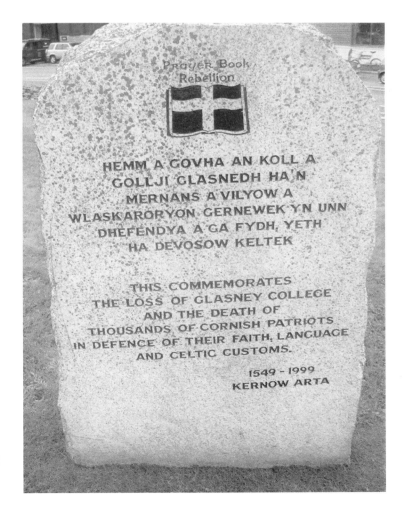

Prayer Book Rebellion Monument near the site of Glasney College, Penryn. (Author's collection)

St Anthony Head Battery

Built in 1895–97 to help the Pendennis and St Mawes castles defend the estuary of the River Fal, St Anthony Head Battery was installed with two BL 6-inch Mk VI naval guns, which were situated in various places throughout the First World War, with the area mainly being used for Army training. The Second World War saw the battery re-armed with two 6-inch VII guns and an extra two Ordnance QF 3-pounder Vickers in new positions. When the site was decommissioned in 1956, the two gun emplacements were actually infilled with rubble and earth, and it wasn't until 2012 that the eastern gun emplacement was excavated and restored by the National Trust.

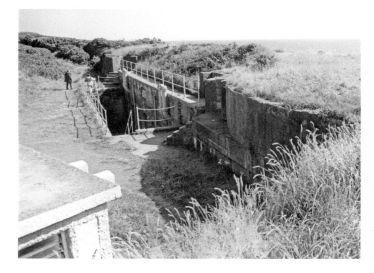

Left: St Anthony Head Battery. (Author's collection)

Below: Officers Barracks at St Anthony Head. (Author's collection)

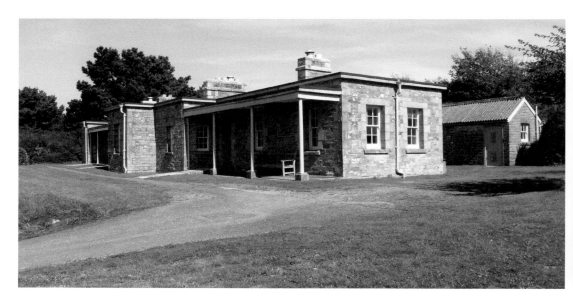

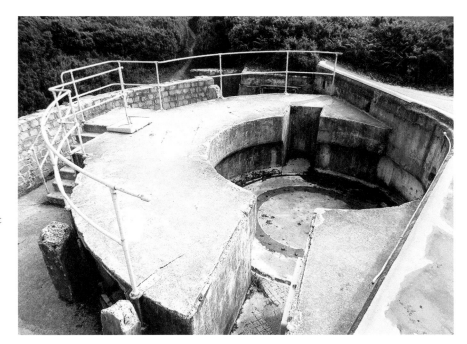

The recently excavated emplacement for a 6-inch BL gun at St Anthony Battery. (Courtesy of Ashley Smith CC BY-SA 4.0.)

St Mawes Castle

With the increased tensions between England and France and the Holy Roman Empire, King Henry VIII ordered more forts to be constructed along the English coastline. The stretch of water known as Carrick Roads at the mouth of the River Fal was an important anchorage point for shipping, and there were original plans for five castles to be built in the area. However, due to the expense, only two were built: Pendennis Castle and St Mawes Castle. Their guns provided overlapping firepower across Carrick Roads, and St Mawes could also cover a separate anchorage point on the eastern side of the estuary. Completed in 1542, the castle is the shape of a clover and used to be armed with nineteen pieces of artillery. The central tower is 14 metres across and 13 metres high and features a range of typical rooms, including a kitchen, storeroom and officers' quarters.

The central tower is linked to the front and side bastions, each of which forms a gun platform, with embrasures for larger artillery pieces. A small, permanent garrison held residence at the castle, with local militia providing additional support in times of need. War with the Spanish broke out in 1569, and the garrison was strengthened to 100. An additional gun battery was built, and as a result of the failed Spanish Armada of 1597, two earth and timber bastions were built out from the original stone castle to hold guns, eventually becoming the main batteries for the castle. As the threat subsided, in 1623 the castle reduced to a much smaller garrison of 16 men.

In 1642, the English Civil War broke out, and Pendennis and St Mawes Castles were important in defending the supply routes to the continent – and of course, Carrick Roads was still an important place for anchoring The Royal Fleet. As large numbers

of Parliamentarian troops approached, the soldiers at St Mawes quickly surrendered without much resistance; war-weariness and being outnumbered contributed to this decision.

Afterwards, the artillery and guns were taken and used to assist with the siege of Pendennis Castle. The castle continued to operate as a defensive base in the eighteenth and nineteenth centuries. The defence of Falmouth was critical during the wars with France, and from 1775 until 1780 the local militia was called up to help defend St Mawes, which by this point had over thirty pieces of heavy artillery.

In 1805, St Mawes was armed with ten 24-pounder guns, and in 1850, with fears yet again of a French invasion, the castle went through a complete overhaul to ensure it was equipped to defend against the newer iron-made warships. A new Grand Sea Battery was built beneath the castle, equipped with eight 56-pound and four 64-pounder guns. The older part of the castle was used as a barracks but, seeing as it had limited space, it was generally used as a training base. At the start of the twentieth century, it was decided that Pendennis Castle, alongside the newly built St Anthony Battery, could defend the area from attack, so St Mawes lost its military significance and was disarmed.

During the First World War, the castle was used as a barracks for the nearby St Anthony Battery. In 1939, at the start of the Second World War, the British Army took control of the site, with No.173 Coast Battery taking over in 1941 with a new, twin 6-pounder battery, a Bofors anti-aircraft gun and searchlights at the base of the Grand Sea magazine. Although removed from active service in 1945, the gun battery was still used as a training facility until 1956, and by 1970 much of the Victorian concrete defences were cleared from the Grand Sea Battery and the 1941 battery was completely destroyed. Today, it is a well-maintained attraction that gives an excellent glimpse into its history.

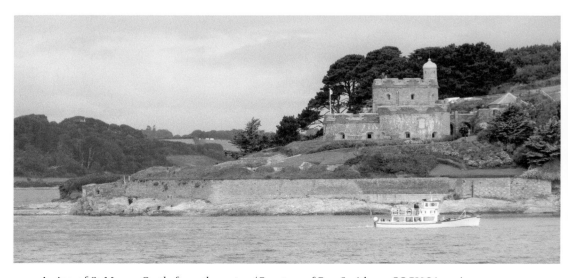

A view of St Mawes Castle from the water. (Courtesy of Ben Smitheon CC BY-SA 2.0.)

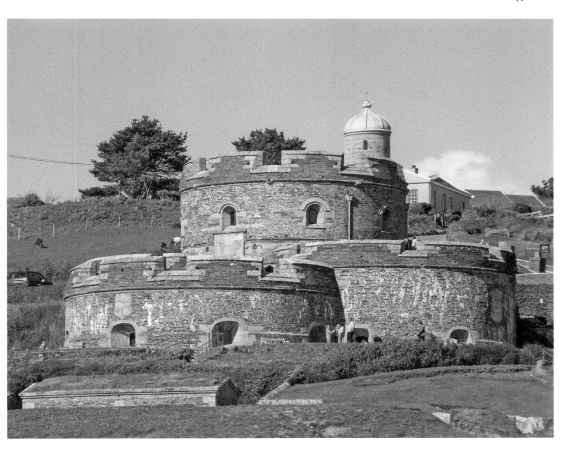

Above: The clover-shaped sixteenth-century keep. (Courtesy of Tim Green CC BY 2.0.)

Right: The Alberghetti Gun at St Mawes. (Author's collection)

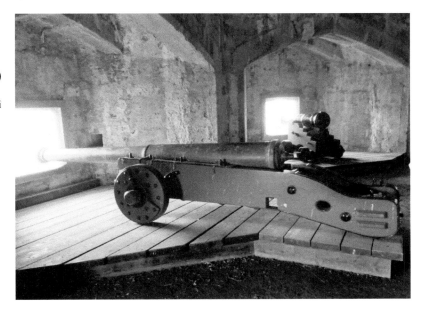

Truro

It isn't surprising to know that the county town of Cornwall once had a very prominent castle. Built in the twelfth century by Richard de Luci, who was granted land by King Henry II because of his work as Chief Justice of England, it was only after it was built that Truro began to develop as a settlement. Thought to have measured over 20 metres in diameter, it lay in ruins by 1270 and the motte is recorded to have been levelled in 1840. As a result, there is nothing left of this castle and Truro Crown Court now stands on the same site.

The English Civil War of the seventeenth century saw Truro establish an impressive force to fight for the King and they even established a Royalist mint within the city, which was then moved to Exeter when the Parliamentarians seized control in 1646.

The First World War saw 182 men from the city killed, and the Second World War saw many children evacuated – on a dark day in August 1942, it was attacked and bombed by German forces, leaving 14 dead.

HTP workshops on Lemon Quay (now the Pannier Market) made aircraft parts, and by 1943 many US troops came to the area in preparation for D-Day, ultimately moving on to the French coast via the nearby ports and harbours.

4. Newquay & St Austell

Battle of Lostwithiel, 1644

During the first English Civil War, one of the most significant battles between the Royalists and the Parliamentarians took place near Lostwithiel between 21 August and 2 September 1644. With the South West being predominantly Royalist territory, the Earl of Essex brought his Parliamentarian force of over 6,000 infantry and cavalry of 3,000 down to the region, helping to relieve the siege of Parliamentarian-held Plymouth, and buoyed by this success, he moved into Cornwall with the aim of claiming the region.

Fearing the potential loss of the whole area, King Charles I set off from Oxford with his army immediately, hoping to deal with Essex before the earl could be reinforced. He arrived in Exeter just as the Parliamentarians were entering Cornwall, and realising they were trapped in the county, the Earl of Essex marched to the small town of Lostwithiel on 2 August 1644, setting up a defensive arc on the high ground near Restormel Castle and Beacon Hill. He also sent a small force to secure the port of Fowey, with the aim of eventually being able to evacuate by sea by Parliamentarian fleet. King Charles followed him, closing off potential escape routes as he went, and arrived with his force of 12,000 infantry and 7,000-man cavalry on 11 August. Securing the east side of the River Fowey and sending artillery to the blockhouse at Polruan (essentially blocking Fowey harbour), the Parliamentarians effectively became trapped with no means of escape. After a few

The River Fowey running through Lostwithiel. (Courtesy of Robert Pittman CC BY-ND 2.0.)

skirmishes, the Royalists reclaimed Restormel Castle and had the Parliamentarians trapped in an area between Lostwithiel and Fowey. Looking to escape, the Earl of Essex ordered his cavalry to break out for Plymouth, which they did successfully, before his infantry ransacked and looted Lostwithiel with the aim of retreating to the south. The Royalist army pursued Essex along the river valley, with many conflicts and counter attacks, before the earl fled at night by boat, forcing the commanders he had left behind to surrender.

Up to 6,000 Parliamentarians were taken prisoner and marched to Southampton, with as many as 3,000 dying of exposure to disease along the way. The battle turned out to be the Parliamentarians worst defeat of the first English Civil War and ensured that the South West remained under Royalist control until the end of the conflict.

Carlyon Bay & Pentewan Beach

The quiet and peaceful surroundings of Carlyon Bay and the neighbouring Pentewan Beach are occasionally compromised by the Royal Navy and British Army

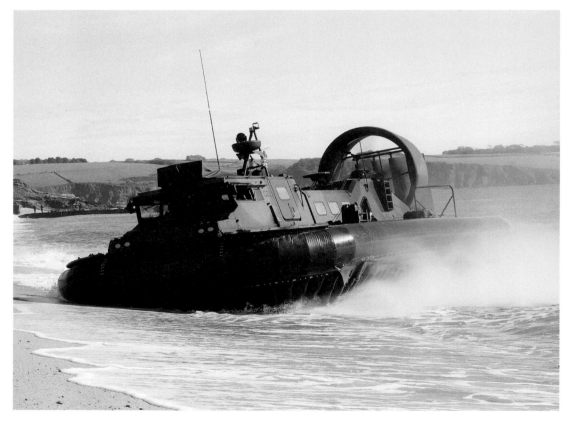

A Royal Marine hovercraft landing on a beach during the Carlyon Bay Wader Exercise. (Courtesy of Open Government Licence 3.0.)

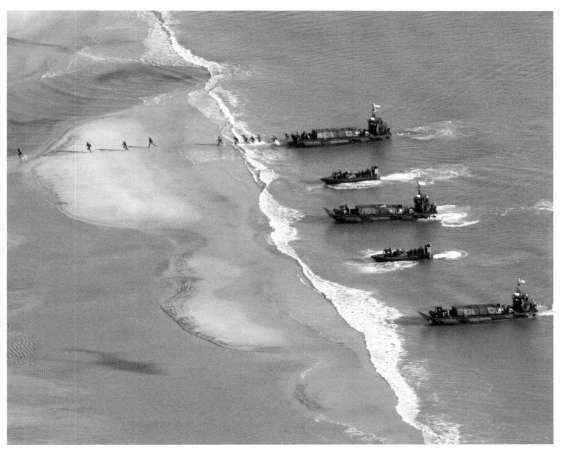

Royal Marines of 40 Commando disembark from their landing craft during an amphibious assault demonstration at Pentewan Beach. (Courtesy of Open Government Licence 3.0.)

using the golden sands of Cornwall for large-scale landing exercises. Testing the ability of the different forces to work together on complex manoeuvres, the Royal Navy and the Royal Marines regularly work together on amphibious exercises in the region.

Castle Dore

The Iron Age hill fort of Castle Dore near Fowey was likely built in the fourth or fifth centuries. It consists of two ditches that surround a circular area of 79 metres in diameter; just inside the ditches are 2-metre-high earth ramparts, which would have acted as an additional defence. The location is said to have contained the hall of King Mark of Cornwall, built in the sixth century. During the civil war, the Earl of Essex and his Parliamentarian army retreated through here whilst attempting to escape from the Royalist's pursuit. Today, only the earthworks remain of this site.

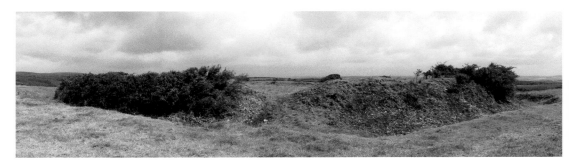

The earthwork remains of Castle Dore. (Courtesy of Ben Smitheon CC BY-SA 2.0.)

Cornwall Aviation Heritage Centre

Located on the former grounds of RAF St Mawgan, the Cornwall Aviation Heritage Centre is situated inside a Hardened Aircraft Shelter (HAS) and boasts a collection of classic aircraft, including jet fighters, bombers and giant in-flight refuelers. A relatively recent operation (it was opened in 2016), one exciting novelty is being able to sit inside the cockpits whilst absorbing the extensive history from the staff that work there. The centre also undertakes certain restoration projects, ensuring that the legacy of these aircraft is continued.

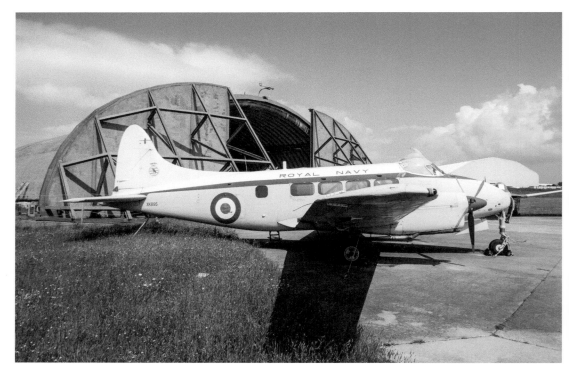

A De Havilland DH104 Sea Devon, used by the Navy, sits outside the huge, hardened aircraft shelter. (Courtesy of Steve Lynes CC BY 2.0.)

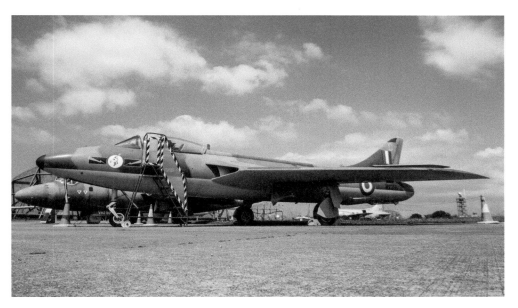

A Hawker Hunter GA11 at the Cornwall Aviation Heritage Centre. (Courtesy of Steve Lynes CC BY 2.0.)

St Columb Major, Castle an Dinas

On the summit of Castle Downs near St Columb Major, the impressive Iron Age hill fort of Castle an Dinas remains. There sit three defensive ditches believed to date from the second century BC, and legend has it that it was the hunting lodge of King Arthur.

In March 1646, during the first English Civil War, Royalist troops camped here for two nights.

The defensive earthworks of Castle an Dinas. (Author's collection)

St Columb Major, POW Camp 115

During the Second World War, a large number of prisoner-of-war camps were built across the country, and POW Camp 115 was built at White Cross, not far from St Columb Major.

Spanning 12 acres, around 1,000 prisoners were held here in white concrete huts, spurring the construction of a central water tower. At first, Italian prisoners were held here, where they levelled the ground to make a football pitch and even built their own church, complete with altar. As the war continued, the Italians were moved elsewhere, and German POWs were brought in.

It is interesting to note that the 1952 Olympic bronze medallist and four-time world record holder in the breaststroke, Herbert Klein, was held there. Today, a holiday park stands on the site, and the water tower is now used as a workshop.

RAF St Mawgan

Staring its life as a civilian airfield in 1933, the site was requisitioned in 1939 and named RAF Trebelzue and used as a satellite airstrip for nearby RAF St Eval. However, it was soon redeveloped with extra runways and renamed RAF St Mawgan in February 1943.

In June 1943, the US Army Air Force took over and built a new control tower, using the airfield for the remainder of the conflict.

Although initially closed for maintenance in 1947, it was reopened in 1951 as a Coastal Command station, conducting maritime reconnaissance, and was the last remaining US Navy installation in the country.

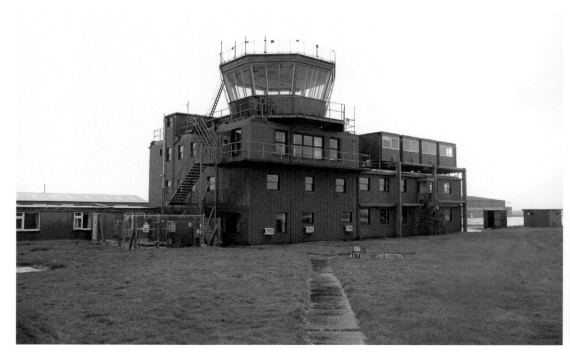

The control tower at RAF St Mawgan. (Courtesy of Richard E Flagg)

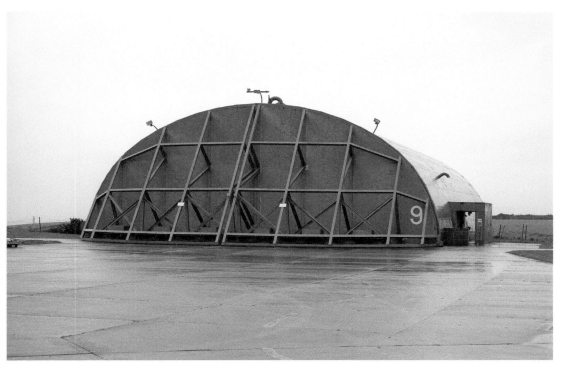

One of the hangars on site. (Courtesy of Richard E Flagg)

Many buildings still remain at the airfield. (Courtesy of Richard E Flagg)

After the Cold War, the site was mainly used as a search and rescue training camp and the home of No. 203(R) Squadron, equipped with Westland Sea King helicopters.

Although reduced in size, RAF St Mawgan is still partly used by the military today as the home to the Defence Survival Training Organisation (DSTO), teaching 'Survive, Evade, Resist, Extract' methods to the armed forces.

St Catherine's Castle

Built between 1538 and 1540, St Catherine's Castle is a small two-storey D-shaped fort, constructed to protect Fowey harbour in response to the deteriorating situation between England, France and the Holy Roman Empire.

With an invasion now seemingly imminent, King Henry VIII began improving his coastal defences, and the two blockhouses positioned along the river's edge – the Fowey and Polruan blockhouses – were upgraded with this structure that was located on the headland, overlooking the entrance to the estuary. Known as St Catherine's Point, the castle takes its name from this, and was equipped with five gun ports for cannons and protected with a curtain wall built over the already steep cliffs. Only measuring 5x4 metres, the ground floor had three semicircular gun ports overlooking the sea and the estuary, and the first floor was equipped with two more, as well as windows that could have been used for smaller weapons. Inside, there was a fireplace, chimney, and a small guard chamber by the entrance, whilst the curtain wall had slits for firing muskets and surrounded around 500 square metres.

During the English Civil War, the site was held by the Royalists, although there is no record of any real fighting. In the years that followed, it was maintained by the locals,

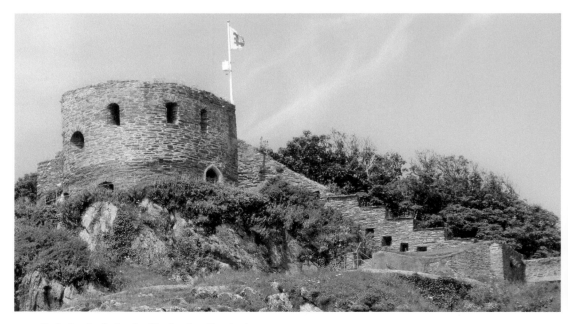

St Catherine's Castle. (Author's collection)

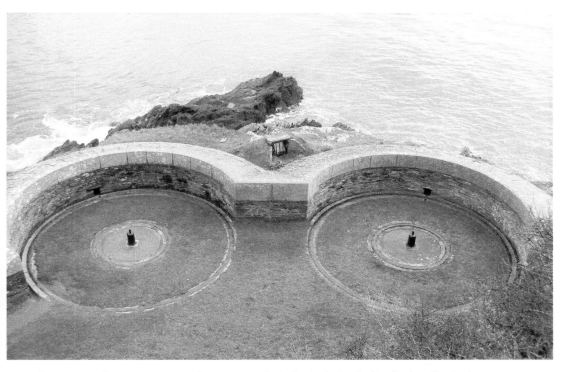

The nineteenth-century gun emplacements at St Catherine's Castle. (Author's collection)

and by the time of the Napoleonic Wars of 1815 was equipped with six cannons. The castle was redeveloped in 1855 with two new gun positions being built in response to the Crimean War, and in 1887 the castle was equipped with new 64-pound muzzle-loading artillery pieces.

By the turn of the twentieth century, the site was no longer used, but the Second World War saw British Southern Command re-arm the site in 1940 as an observation post and gun battery. Manned initially by 364 Coast Battery of the Royal Artillery, two naval guns were installed on the existing structure and new concrete defences were built nearby. The estuary was mined and following 379 Battery of the 557 Coast Regiment being stationed here, the site was retired from active operations as the threat of German invasion receded in 1943. It is now maintained by English Heritage and is free to visit any time of the year.

Trelow Downs Decoy Airfield

Just to the north-east of RAF St Mawgan and to the east of RAF St Eval, the Trelow Downs decoy airfield was built during the Second World War as a way of tempting Luftwaffe bombers to drop their payload on the open fields, rather than either of the two real airfields. By giving the impression of a partially blacked-out facility, the site did receive attention from the German Air Force during night-time raids, leaving the real airfields nearby unscathed.

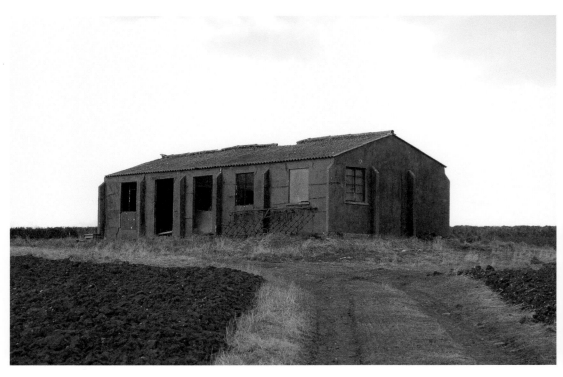

A crew hut at the Trelow Downs decoy site. (Courtesy of Richard E Flagg)

5. North Cornwall

Bodmin

The town of Bodmin has been directly involved in no fewer than three rebellions over the years. Thomas Flamank, a lawyer from Bodmin, was one of the main leaders of the Cornish Rebellion of 1497, and then in the autumn of that same year, when Perkin Warbeck tried to prise the throne from King Henry VII, he was proclaimed King Richard IV in the town.

In 1549, the Prayer Book Rebellion saw men from the town marching across the border into Devon to lay siege to Exeter, but this too ultimately ended in defeat.

Bodmin is home to Cornwall's Regimental Museum, which is located at Bodmin Keep. Built in 1859, it was originally a depot for the Cornish militia and volunteers and became the headquarters for the Duke of Cornwall's Light Infantry in the 1880s.

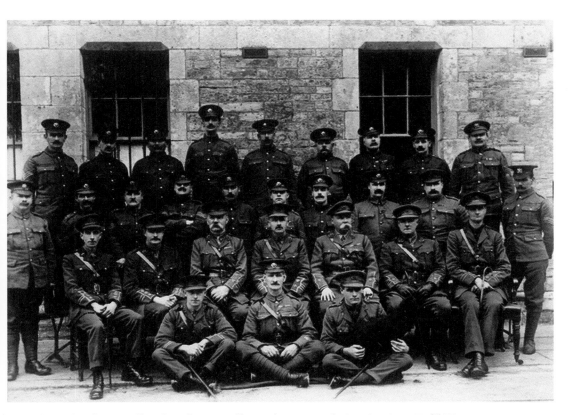

The Duke of Cornwall Light Infantry staff at Bodmin Keep during the First World War.

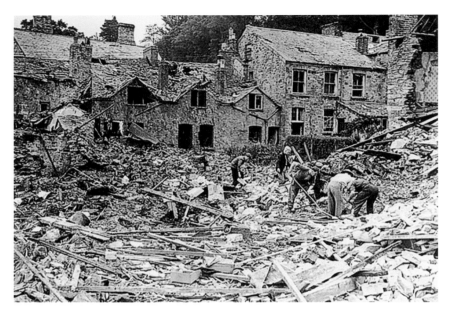

Left: Bomb damage in Bodmin in 1942.

Below: Bodmin Keep and its war memorial today. (Author's collection)

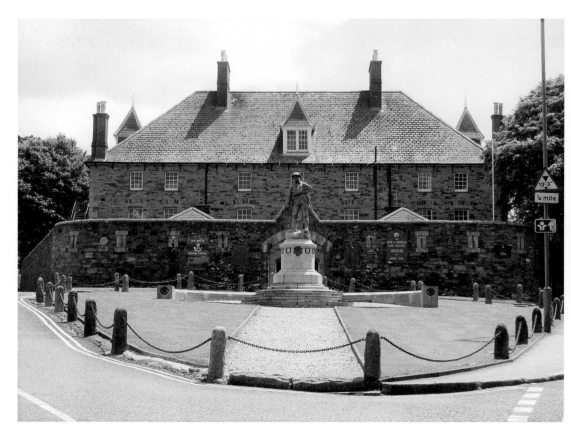

42 Commando Royal Marines on an exercise on Bodmin Moor. (Courtesy of Open Government Licence 3.0.)

By the early twentieth century, the site had grown to include living quarters, a hospital, and an officers' mess, soon becoming known as Victoria Barracks. During the First World War, more than 2,000 soldiers would be here at any one time, as the barracks was used as a training facility for new recruits before they were sent into battle. The town's war memorial is located in front of the Keep and was unveiled by the Prince of Wales in 1924. The barracks was still in use by the regiment during the Second World War, and like most towns during this conflict, Bodmin was subject to enemy interest. On 7 August 1942, two German aircraft dropped a succession of bombs and cannon fire over the town, killing nine and injuring eighteen. In May 1944, US forces moved in and occupied the site, extending it and using it for training in the run-up to D-Day. After the Second World War, a foreign language school was established at Bodmin Barracks in 1951 as part of the nation's Cold War effort.

Victoria Barracks was eventually closed as an actual operational site in 1962, seeing most of the facilities being sold off – all except the Keep. Today, the Keep houses the museum, which preserves the extensive history of this site and the Duke of Cornwall's Light Infantry, where a fine collection of medals, weapons, uniforms, paintings and artefacts are clearly displayed for all to see.

The current regiment – The Rifles – was formed in 2007 by amalgamating the Devon and Dorset Light Infantry, the Royal Green Jackets, the Light Infantry and the Royal

Gloucester, Berkshire and Wiltshire light infantries into one large regiment, which still houses its county offices at Bodmin Keep, while Bodmin Moor is still use by the military for training exercises.

Boscastle (Bottreaux) Castle

Built in the twelfth century, Bottreaux Castle was a traditional earth-and-timber ringwork defence constructed by the Bottreaux family. Not much is known about the castle today – by the fifteenth century, it was listed as a manor house and very little of it remains today. Instead, a cottage sits in its previous location, while a steep hill is the only clue to its past.

Old Cardinham Castle

In the aftermath of the Norman Conquest of 1066, Robert, Count of Mortain (who was William the Conqueror's half-brother) seized much of the land in the parish which had belonged to the priory in Bodmin. He had the castle built to protect this land from the irate locals, and this earthwork motte-and-bailey fortress was built on high ground to the south of the church – although the vague shape of the castle can still be seen, there are sadly no ruins.

RAF Cleave

Built in 1939 to the north of Bude, RAF Cleave was used predominantly to store targets and target-support aircraft for the various firing ranges along Cornwall's north coast during the Second World War.

A naval steam catapult was constructed near the cliffs for the pilotless Queen Bee aircraft while anti-aircraft co-operation squadrons were stationed here for the duration of the war. Runways, hangars and the usual associated buildings were all on site, but it ceased operations in April 1945. The land at Cleave was allotted to the Ministry of Public Buildings

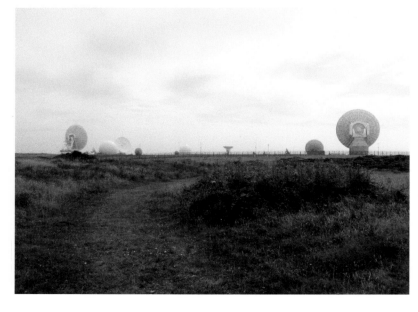

The current site of GCHQ Bude. (Author's collection)

and Works in 1967, and then the construction of a satellite interception station started in 1969. Known as GCHQ Bude and operated by the British Signals Intelligence service, it is a UK Government satellite ground station, equipped with twenty-one satellites.

RAF Davidstow Moor

Built in 1942, this three-runway airfield is based in a moorland location and could only be constructed upon the removal of various field boundaries, the closure of minor roads and drainage work.

Part of RAF Coastal Command, aircraft from here were mainly used in anti-submarine patrols and search and rescue missions – although they did also help cover the western flank of the Normandy landings in 1944.

RAF Davidstow Moor closed in December 1945 at the end of the Second World War, with many of its buildings quickly removed, although the old air traffic control tower, a two-storey turret building, now used for training purposes, are still there today. While the airfield is still partially used by Davidstow Flying Club, the Davidstow Airfield and Cornwall at War Museum has been built here to commemorate the work and people of RAF Davidstow Moor.

The museum is a must-visit, as it houses many exhibits about life in the Second World War in Cornwall from the perspective of the RAF, the Royal Navy, the Army and the home front. These are all on display in some of the airfield's original buildings, featuring a large hangar filled with aircraft and vehicles, as well as the opportunity to take an airport tour and visit an air raid shelter – overall, it is a fitting tribute to those who fought for our freedom.

Just across the road is the separate Davidstow Moor RAF Memorial Museum, which is located in the former sergeants' shower block and focuses specifically on the airfield's history during the Second World War through archive photographs and memorabilia.

The now derelict control tower at RAF Davidstow Moor. (Courtesy of Richard E Flagg)

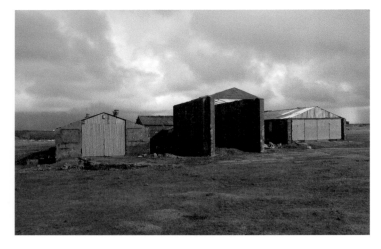

The main stores and offices.
(Courtesy of Richard E Flagg)

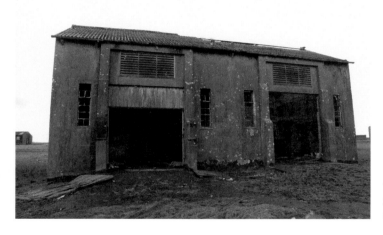

The two-storey turret
instructional building.
(Courtesy of Richard E Flagg)

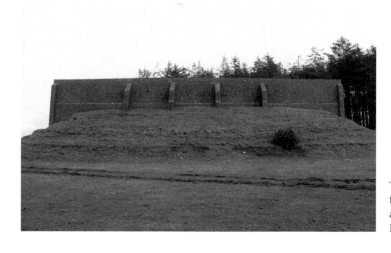

The huge brick stop-butt of a
firing range within the wider
airfield site. (Courtesy of
Richard E Flagg)

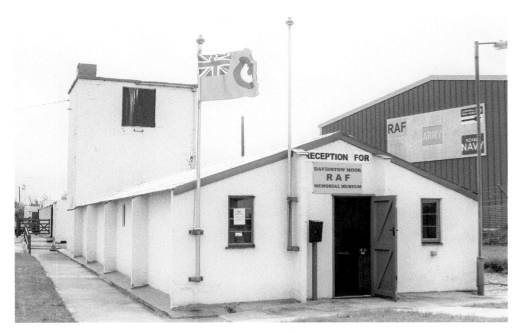

RAF Davidstow Moor Memorial Museum. (Author's collection)

Lanhydrock House

During the Second World War, Lanhydrock House became a home for evacuees who had moved out of the big cities. It is also mentioned that the vast estate was used to store ammunition and that army battalions camped out here, using the thick tree coverage to hide from enemy planes above.

Launceston Castle

In the aftermath of the Norman Conquest of 1066, Robert, Count of Mortain was granted the title Earl of Cornwall, which entailed ownership of this strategically placed castle, controlling the area between Bodmin Moor and Dartmoor, as well as access over the Polson Ford into Cornwall.

Recorded in the Domesday Book, the motte-and-bailey castle would have had wooden ramparts to begin with. It is thought that the circular keep, stone gatehouse, towers and walls were likely to have been built in the late twelfth century.

In 1227, under Richard of Cornwall, the castle defences were improved, with the height of the keep being increased and a new great hall being built in the south-west corner. In 1272, this administrative hub moved to Lostwithiel to be closer to the tin mining industries, leading to the decline of Launceston Castle.

A survey in 1337 reported lots of issues with the now poorly maintained fortification; after repairs a few years later, the castle became used as a prison. It was eventually seized by the locals during the Prayer Book Rebellion of 1549, where they imprisoned the royalist leader Sir Richard Grenville inside the castle, and he died during his detention there,

before it was retaken by the Crown. The castle was in the possession of the Royalists when the first English Civil War broke out, until it was taken by Parliamentarian forces in 1646. In the late seventeenth century, a gaol was built in the centre of the bailey, which then became the county jail until 1823. Executions were carried out here, and it had a reputation for filthy and unhealthy conditions.

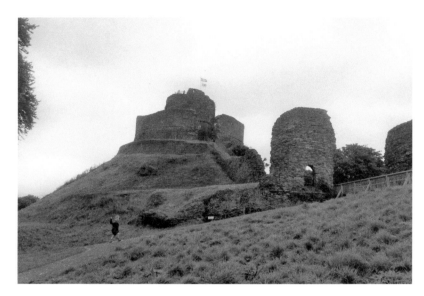

Launceston Castle. (Author's collection)

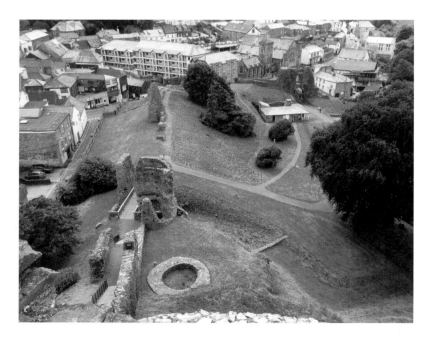

The view of Launceston from the top of the keep. (Author's collection)

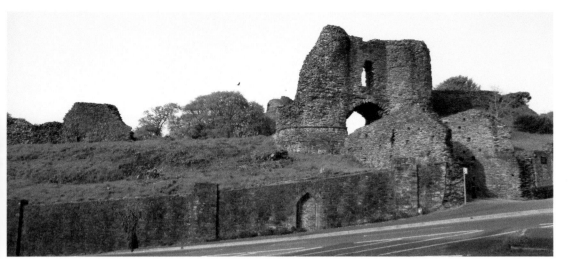

View of the ruined gatehouse and curtain wall. (Author's collection)

A fascinating local legend has it that Queen Maria II of Portugal complained about the condition of the site to Queen Victoria whilst on a visit to the area. This resulted in the gatehouse being repaired and the area being landscaped by Hugh Percy, the 3rd Duke of Northumberland and the castle's personal constable, between 1840 and 1842 to create a public park.

During the Second World War, the castle grounds were used to hold a set of temporary Nissen huts as a hospital for the US Army. The castle is now maintained by English Heritage and open to the public.

Launceston POW Camps

During the Second World War, Launceston had two prisoner of war camps: Camp 257 at Pennygillan Farm and Camp 406 at Scarnecross. Both housed Italian and German soldiers during the conflict, and these men were often forced to help with work on the farms.

Prideaux Place

This luxurious Elizabethan manor house is on the outskirts of Padstow. It was the stately home of the 121st Engineer Combat Battalion of the American Army, who marched proudly from Prideaux to take up their role in the D-Day landings.

Penstowe Castle

Penstowe Castle (also known as Kilkhampton Castle) was a twelfth-century castle built near the village of Kilkhampton. Positioned on a knoll with steep slopes on either side and oval top measures of 18×8 metres, not much else is known about this site – only its indentations remain.

St Eval

With the RAF expanding rapidly in the 1930s, the site of St Eval was chosen to be a vital Coastal Command airfield for the south-west of England, playing a prominent role in anti-submarine and anti-shipping patrols in the Bristol Channel, Atlantic Ocean and English Channel. In 1938, the tiny village of St Eval was demolished to make way for the airfield's construction, although the church remained in situ, becoming the station church, and it still stands today. Opening on 2 October 1939, No. 217 Squadron arrived, providing a maritime patrol role along the Western Approaches.

In June 1940, the station became a RAF Fighter Command headquarters armed with Spitfires, Hurricanes and Bristol Blenheim fighters, taking an active role in the Battle of Britain. December 1940 saw the formation of 404 Meteorological Flight RAF, who stayed at St Eval for the duration of the war, providing vital weather data on which the Coastal Command meteorologists could base their forecasts. Unsurprisingly, the airfield was a target for the German Luftwaffe, and it was hit a number of times in the summer of 1940, early 1941 and May 1942. As well as protecting shipping in the Western Approaches, aircraft from here participated in anti-submarine operations in the Bay of Biscay and strategic attacks over the north-west of France.

In October 1942, the US Airforce began to use the station in a boost to anti-submarine operations, and many troops attacked by flying out specialised long-range B-24 Liberator bombers equipped with RADAR and other submarine-detection equipment until the US forces moved out in August 1943.

One of the buildings that remains at St Eval. (Courtesy of Richard E Flagg)

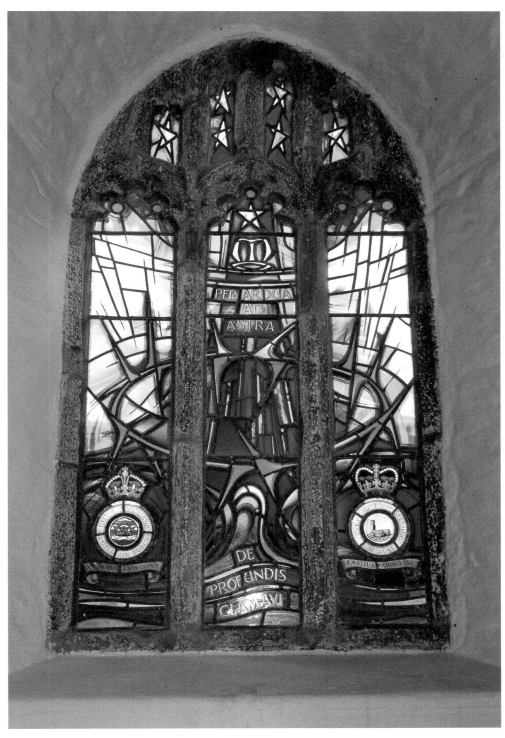

The stained-glass memorial window in the Church of St Ulvelus. (Courtesy of Richard E Flagg)

In early 1944, St Eval was given a FIDO installation (a system used for dispersing fog) so that aircraft could land safely in all weathers. The station had one of the most powerful anti-submarine forces in the allied army, with thousands of patrols being flown each month, ensuring goods, materials and food continued to arrive in the country. The airfield was hugely busy in the build-up to D-Day, but by the summer and autumn of 1944, many squadrons moved across to northern France and the airfield's traffic was significantly reduced.

After the war, the station continued to be used for maritime patrols, search and rescue duties, and as a diversion site for emergency landings. On 6 March 1959, the station closed, and all remaining squadrons moved to RAF St Mawgan, with the airfield becoming home to the transmitters and aerial farm used for communications by Nimrods. Although the basic structure of the airfield still exists, many of the associated buildings have long since gone. The site is currently the base for a high-frequency transmitter station, which forms part of the Defence High Frequency Communications Service. The station's former church, St Ulvelus, has a Book of Remembrance and a memorial window to those from the airfield who fought in the war.

RNAS St Merryn

Built in 1937 to the north-east of Newquay as a civilian airfield, RNAS St Merryn is a former Royal Naval Air Station of the Royal Navy's Fleet Air Arm. With four concrete runways, it was known as HMS Vulture, a training base for carrier-borne fixed wing fighters. After the Second World War, in 1952, the site recommissioned as HMS Curlew as a base for ground

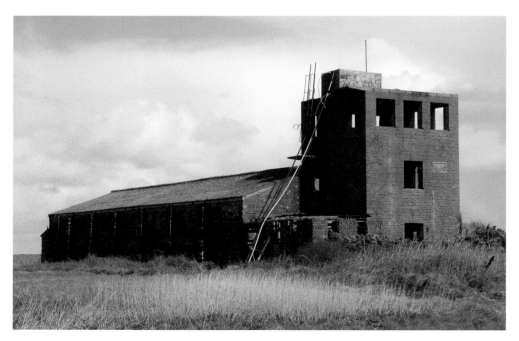

The ruined control tower of RNAS St Merryn. (Courtesy of Richard E Flagg)

Aircraft shooting-in butts. (Courtesy of Richard E Flagg)

One of the many hangars on site. (Courtesy of Richard E Flagg)

The former barrack blocks are now used for agricultural storage. (Courtesy of Richard E Flagg)

training until it closed 1956. The site is still used for a small amount of civilian air traffic, and onsite there are several derelict buildings that pay homage to its military past.

Tintagel Castle

Located on the peninsula of Tintagel, the atmospheric ruins of Tintagel Castle give us a glimpse of what would have been a visually stunning fortification. The site was probably originally occupied by the Romans, but the first recorded structure built here was a castle constructed by Richard, 1st Earl of Cornwall in 1233.

It is said that the castle was likely built in an old-fashioned style to appear more ancient, an attempt at forging a connection with the ancient Arthurian legends. In the years that followed, the various earls of Cornwall lost interest in the castle, likely due to its difficult position to access, leaving parts of the structure to be used as a prison and the land being used as pasture.

In the 1330s, the roof of the Great Hall was removed, and with significant erosion of the isthmus (the narrow piece of land connecting the peninsula to the mainland) the castle became more and more ruinous. When England was threatened with invasion from Spain in the 1580s, the defences of the site were strengthened at the Iron Gate – although the castle had little strategic importance given its condition. In the Victorian era, there was a fascination with the Arthurian legends and the ruins of the castle became a tourist destination. This was aided by Lord Tennyson's *Idylls of the King*, published in the late nineteenth century, which mentioned a 100-metre-long sea cave dubbed 'Merlin's Cave' at Tintagel. It's no doubt that the jagged coastline, the crashing waves and the crumbling walls have helped cement the mysticism of this place.

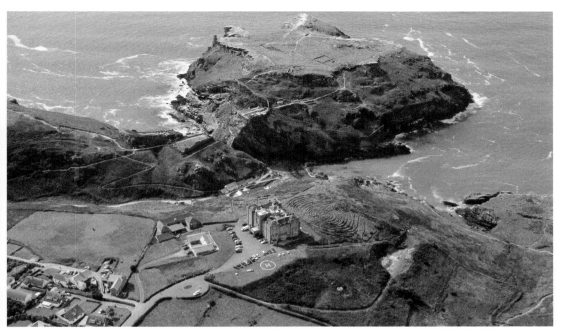

An aerial view of the peninsula that Tintagel Castle sits on. (Courtesy of John Fielding CC BY 2.0.)

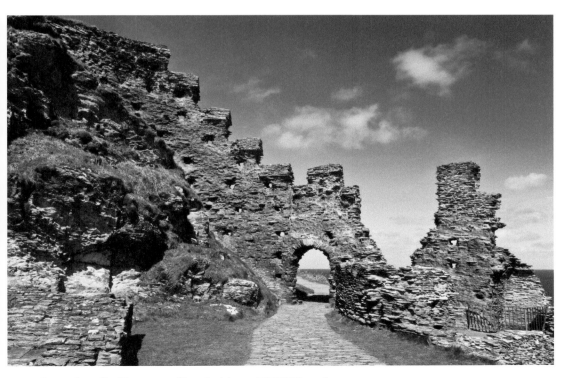

The castle walls. (Courtesy of Ben Smitheon CC BY-SA 2.0.)

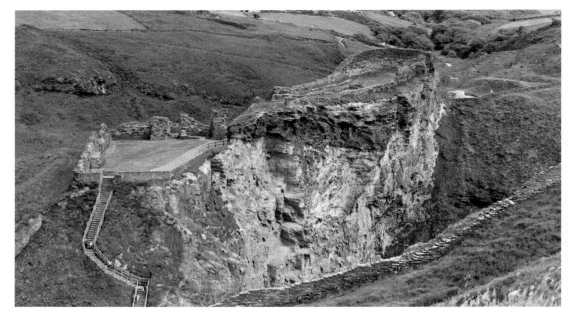

The clifftop ruins at Tintagel. (Courtesy of Michael Hutchinson CC BY-SA 2.0.)

Warbstow Bury

One of the largest earthworks in Cornwall, Warbstow Bury is an Iron Age hill fort on the outskirts of a village of the same name. Situated in a strategic position on a hill at the meeting point of the two tributaries of the River Ottery, the oval enclosure covers 19 acres, protected by 5-metre-high ramparts and 2-metre-deep ditches.

The rampart and ditch at the south of Warbstow Bury. (Courtesy of David Hawgood CC BY-SA 2.0.)

Week St Mary Castle

Week St Mary Castle was built after the Norman Conquest on top of some high ground just outside the old village of 'Wick', likely placed on a trade route only 2 miles from the River Tamar. A small earth and timber fortification measuring around 40 metres in diameter was constructed, surrounded by a ditch, and it is thought that by the thirteenth century the castle was no longer used. Today, nothing remains except some eroded foundations.

6. South East Cornwall

Cawsand Fort

Cawsand is an idyllic place to visit now, but it in 1779 a Franco-Spanish fleet of sixty-six boats anchored in the bay with the intention of landing 30,000 soldiers. Their aim was to seize the high ground overlooking Plymouth and bombard it, but thankfully a storm put paid to their ideas, and with that Cawsand was fortified.

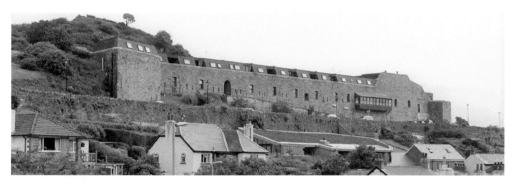

Cawsand Fort – now housing. (Author's collection)

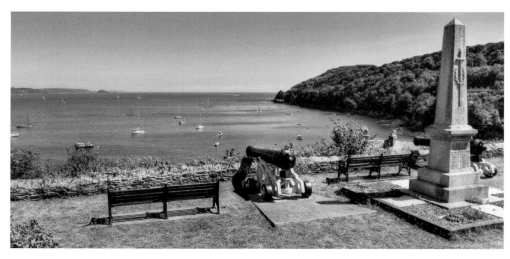

A beautiful view of Cawsand Bay and Plymouth Sound, from what remains of one of the old fort's walls. The war memorial on the right commemorates men of the parish of Rame who gave their lives in the two world wars. (Author's collection)

Pemberknowse Fort was constructed at Cawsand beach, and in the nineteenth century it was redeveloped so that there were nine guns facing seaward (covering Cawsand Bay itself) and a further fourteen guns to protect the fort from a landward attack. The fort was garrisoned into the early part of the twentieth century, including the First World War, but was later released by the military in 1926 and has since been converted into housing.

Ince Castle

More of a manor house than a true castle, the first house here was built in the late fourteenth century, before the Killigrew family took control of it and remodelled it into the place we see today. Henry Killigrew, the Royalist MP for West Looe, modified the house around 1642. It is said that he added four three-storey towers, with walls 1.2 metres thick, to house four wives, one in each tower.

During the English Civil War, Ince castle was captured by the Parliamentarians in 1646 without any bloodshed and with little damage done to the building itself. However, in 1988, the building burnt down, but it has since been rebuilt and, although privately owned, the gardens are occasionally opened to the public.

Mount Edgcumbe

Built during the Tudor period in 1547, protecting the mouth of the River Tamar, a single-storey artillery blockhouse was the first of the defences on the shores of Mount Edgcumbe.

The Tudor-built blockhouse at Mount Edgcumbe. (Author's collection)

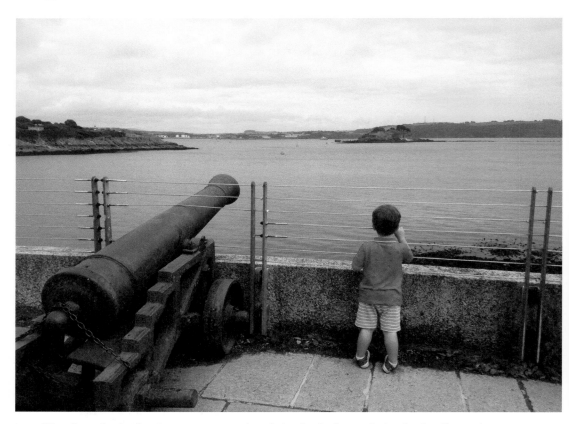

View from the Garden Battery out toward Drake's Island, Plymouth. (Author's collection)

When the Royal Commission of 1859 recommended the construction of a chain of forts around key Royal Navy dockyards, work commenced on developing and improving the Garden Battery in 1862. Designed to work with Drake's Island Battery and protect the main deep-water channel, a new curved structure held seven 9-inch rifled muzzle loading guns, enclosed in iron-plated casemates.

By 1870, the Defence Committee deemed the Garden Battery to be of little use as it was located behind the main outer defensive line, so it was disarmed. However, in 1891 it was re-armed with guns, and by 1899 four 12-pounder quick-firing guns had been fitted alongside two machine guns. It remained armed during the First World War, and although it was decommissioned in 1927, the Second World War saw it reactivated and rearmed. Mount Edgcumbe House itself was destroyed by German bombers during the 1941 Blitz on Plymouth, and although rebuilt since, a small part of that derelict building still stands in the garden as a reminder. US troops were stationed at Mount Edgcumbe Country Park during the Second World War and left from Barn Pool Beach, heading for the horrors that lay in wait on Omaha Beach during the D-Day landings.

Picklecombe Fort

Commissioned in the mid-nineteenth century, around the same time the Royal Commission of 1859 advised the construction of chains of forts around key Royal Navy dockyards, Picklecombe Fort was the western defence for Plymouth Sound. Built near an earlier earthwork battery dating to the start of the nineteenth century, it was constructed between 1864 and 1871 and armed with forty-two 9-inch and 10-inch muzzle loading guns, which were positioned in a huge semicircular arc of two-storey casemates. Rearmed in the 1890s, the fort was never used in conflict, and its guns were removed in the 1920s. However, the Second World War saw the 566th Devon Coast Regiment, Royal Artillery take control of the fort, and two 6-inch guns and two twin 6-pounder guns were installed, alongside a range finder and searchlight positions to the west.

Decommissioned after the war, it stood derelict for years before being converted into residential apartments. Just behind it, the rather imposing old officers' mess building stands overlooking the main fort complex, and this too has been turned into flats.

Fort Picklecombe is now residential apartments. (Courtesy of Simon James CC BY-SA 2.0.)

Polruan Blockhouse. (Courtesy of Robert Pittman CC BY-ND 2.0.)

Polruan

The 1380s Hundred Years' War was heading out of favour of the English, which led to the residents of Fowey fearing they would become a target of French raids. As a result, they built two rectangular blockhouses: one in Fowey and one on the opposite bank at Polruan. Despite thick stone walls and internal gun positions, they could not stop a French attack in 1457, so a thick chain was used across the channel to block access for any enemy ships, while the blockhouses continued to be manned.

In the first English Civil War, Royalists secured full control of the Polruan Blockhouse and the high ground opposite the harbour, which denied access to the Parliamentarian fleet during the 1644 Battle of Lostwithiel. Today, the blockhouse stands in fairly good condition.

Rame Head

So many of these forts in the south-east of Cornwall are located on the Rame Peninsula, and there is evidence of an Iron Age hill fort at Rame Head. At Penlee Point, Penlee Battery was constructed around 1890 as part of the defensive ring around Plymouth. It was armed with two 6-inch and one 13.5-inch BL naval guns and remained in operation during the First and Second World Wars.

The battery was disarmed in 1956, and during the 1970s most of the site was demolished, with the gun positions filled. This same battery is now a nature reserve.

Above: The view from
Penlee Battery. (Courtesy
of Ben Smitheon
CC BY-SA 2.0.)

Right: Polhawn Fort.
(Courtesy of Ben
Smitheon CC BY-SA 2.0.)

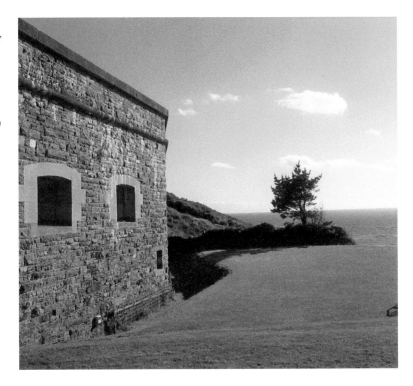

Another site here is Polhawn Battery. Built in 1864, the two-storey structure overlooks the bay, with the upper floor consisting of seven casemates which used to house 68-pounder guns, whilst the lower floor made up the accommodation and a magazine. During the First World War, the battery was used for accommodation for gunnery officers and the magazine was used as a military detention cell. Sold by the War Office in 1927, it became a hotel and tea-room, changing its name to Polhawn Fort in the process. Today, it is a popular hotel and wedding venue.

Restormel Castle

Located on high ground that once overlooked the main crossing point of the River Fowey, Restormel Castle is a well-preserved shell keep castle that was originally constructed in the aftermath of the Norman Conquest of England in 1066. Starting its life as a traditional wooden motte-and-bailey castle for Baldwin Fitz Turstin around the year 1100, it was built at the centre of a large deer park, meaning it was probably also used as a hunting lodge as well as a fortification to keep the locals in check.

When Robert de Cardinham became Lord of the Manor between 1192 and 1225, he developed the castle and built the stone inner-curtain walls and converted the gatehouse into the stone structure that is still standing. The wall measures 38 metres in diameter and is over 2 metres thick. At a height of over 7 metres and with a ditch 15 metres wide and 4 metres deep, it would have been an impressive fortress in its day. Inside the walls, a kitchen, hall, living chambers and a chapel were built in a curved style to fit into the shell keep.

As the castle grew in importance, so did the nearby town of Lostwithiel, and in 1264 Simon de Montfort took the castle, without bloodshed, before it was seized back a year later by Sir Ralph Arundell.

Richard of Cornwall, the brother of King Henry III, was granted the castle in 1270, and when his son Edmund took over a year later, he made Restormel the main administrative base and his Duchy Palace. It is said that the castle had luxurious living quarters and piped water – something very rare during this period. Edmund died in 1299, with the castle reverting to ownership in right of the Crown and was no longer used as a permanent residence.

By 1337, it had fallen into disrepair, with the contents of the castle being stripped out and removed to other duchy residences. By the time English poet John Leland visited in the sixteenth century, the castle lay in the ruined state that can be seen today, with all timber and lead pipes stripped away, along with much of the stonework.

Despite its dilapidated state, the castle saw its only bloodshed and military action in the seventeenth century, when the ruins were occupied by Parliamentarian forces during the English Civil War. They were then attacked by a Royalist force led by Sir Richard Grenville in August 1644, and from this point onwards the castle lay abandoned. Today, it is run by English Heritage and open to the public.

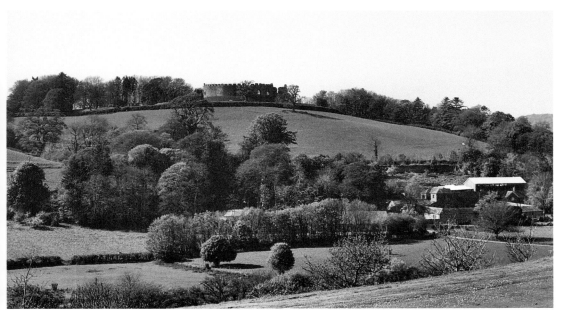

Restormel Castle dominates the surrounding area. (Courtesy of Robert Pittman CC BY-SA 2.0.)

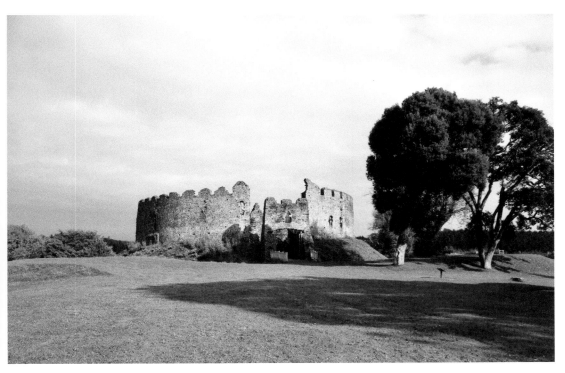

The approach to Restormel Castle. (Courtesy of Robert Pittman CC BY-SA 2.0.)

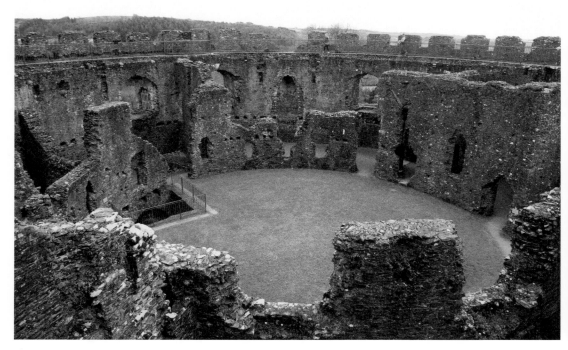

Inside the keep. (Courtesy of Tom Parnell CC BY-SA 2.0.)

Saltash

As gateway to the county, it is not surprising that Saltash, overlooking the River Tamar, has been a vital crossing to Devon for centuries. As a result of this, Trematon Castle was constructed here to help maintain control of this point. In 1884, the ship HMS *Defiance* was commissioned for service as the Royal Navy's Devonport Torpedo School and was moored in the estuary of the River Lynher off Wearde Quay, remaining there until 1930. The First World War saw many men, not just from the town but from all over the county, use the Saltash Ferry to head off to battle, some of which no doubt came from the army training camp at Wearde.

Initially full of hundreds of tents, the main unit stationed here was the 3rd Battalion of the Kings Own Royal Regiment (Lancashire), who had wooden huts built on concrete foundations. By the end of the war, the role of the camp changed to that of a hospital, and on 24 September 1920, it formally converted to the Queen Alexandra's Convalescent Centre, caring for battle casualties. By 1927–28 it closed, with the huts being removed, and the site today is now where the community school is.

In the Second World War, due to its proximity to Plymouth, the town suffered from German bombing – on the night of 28 April 1941, Fore Street came ablaze and eight people were killed. There was also a D-Day landing craft maintenance site, around 200 metres north of Saltash Pier.

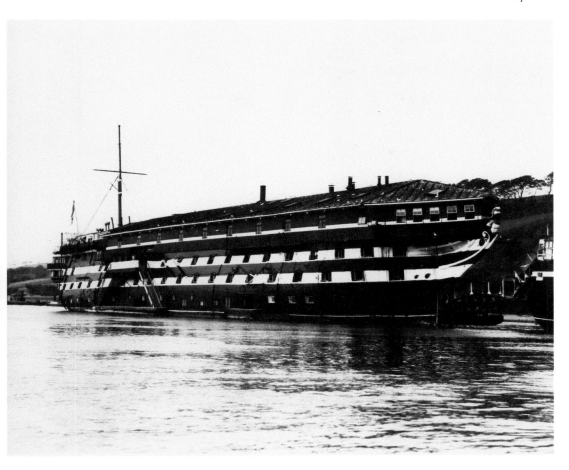

Above: HMS *Defiance* torpedo school ship. (Public domain)

Right: Soldiers leaving Saltash on the ferry during the First World War.

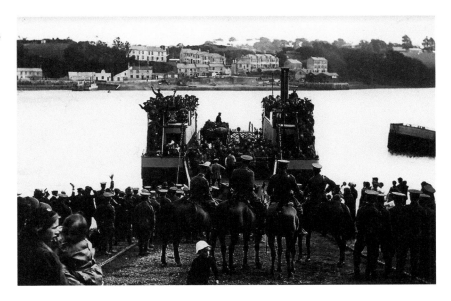

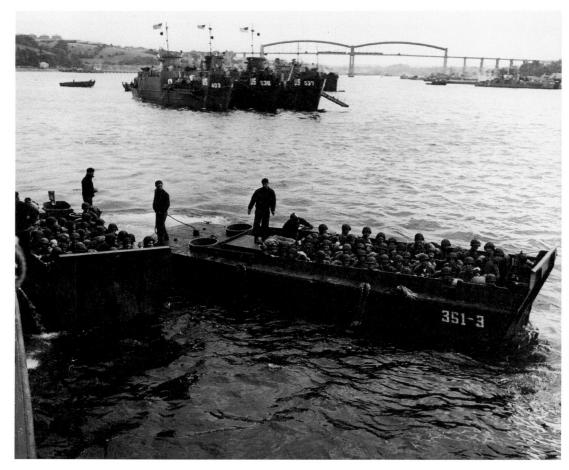

US landing craft in the River Tamar in the build-up to D-Day. (US Army)

The River Tamar estuary was a hive of activity in the run-up to D-Day, and between 1943 and 1945, there was Saltash sub-base of the United States Naval Advanced Amphibious Base (USNAAB) at Plymouth. Built by the 29th and 81st US Naval Construction Battalions, the concrete structure is around 50 metres wide and is now a small car park and jetty on Old Ferry Road.

As with locations right across the country, Saltash has its own Cold War bunker. It was also here, at Winstone Beacon, that an ROC Post (Royal Observer Corp) was established in 1959 and manned until 1968.

Scraesdon Fort

Designed in 1859, the impressive Scraesdon Fort near the village of Antony is one of the many forts in south-east Cornwall that formed part of the late nineteenth-century defences surrounding Plymouth. It was designed to have an impressive twenty-seven

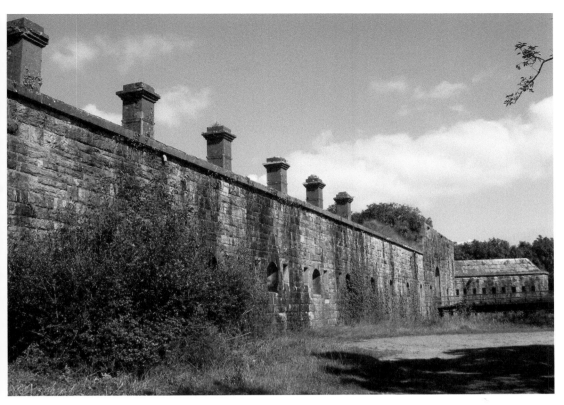

The east wall of Scraesdon Fort. (Courtesy of Ben Smitheon CC BY-SA 2.0.)

7-inch breechloading guns on the ramparts, surrounded by a dry ditch, and was later used by the MoD as a training barracks. Now a Grade II listed building, it is empty and derelict, but it is still sometimes used by Royal Marine Commandos or local Army Reserve units.

Trematon Castle

Robert, Count of Mortain, built the original castle here in the years immediately after the Norman Conquest, with the wooden motte-and-bailey structure being listed in the Domesday Book of 1086. Overlooking Plymouth Sound, the castle was strategically placed to ensure that access for the ferry from Saltash Passage to Plymouth – the only means to cross the River Tamar at this time – was maintained.

The castle and ferry route belonged to the Valletort family until 1270. During this time, the wooden structure was replaced with stone. The oval keep reached to roughly 10 metres high, with its walls 3 metres thick, whilst a two-storey rectangular gatehouse and portcullis was constructed in the thirteenth century, both of which are still standing and in good condition. The stone Norman walls are still evident on the site, although these are in a more ruined state.

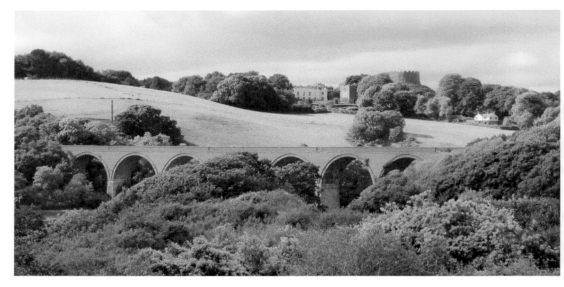

A view of Trematon Castle overlooking the Forder viaduct. (Author's collection)

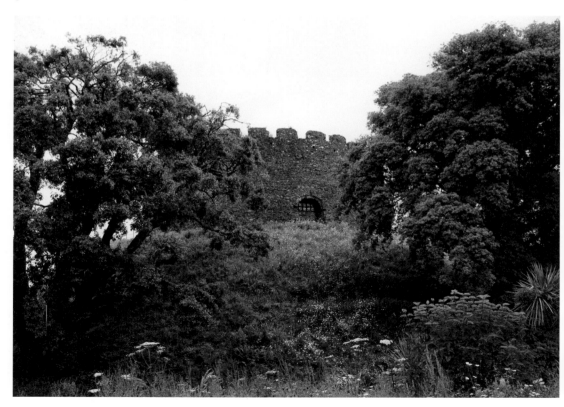

The small motte-and-bailey Trematon Castle. (Courtesy of Ben Smitheon CC BY-SA 2.0.)

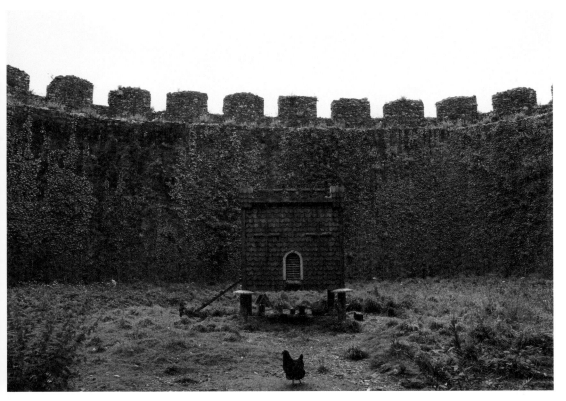

Chickens now live inside the twelfth-century shell keep. (Courtesy of Ben Smitheon CC BY-SA 2.0.)

Since 1270, Trematon has been the property of various earls and dukes of Cornwall, becoming less important as a military stronghold as the centuries progressed and more an expression of power. It is interesting to note that when Sir Francis Drake returned to Plymouth from his circumnavigation of the globe in 1580 – the first Englishman to do this – Trematon Castle was used to store the gold, silver and precious stones that he had pirated from the Spanish along the way, before they were eventually taken to Queen Elizabeth I. Clearly the castle and its walls were still completely intact at this point.

In 1808, a six-bedroomed Georgian house was built in the castle courtyard, demolishing part of the original castle wall to provide better views of the countryside. Now privately owned, the castle is open to visitors on select days throughout the year.

Tregantle Fort

Built in 1865, Tregantle Fort was designed to hold thirty-five large guns, with barrack accommodation for a staggering 2,000 men as part of the ring of defensive locations protecting Plymouth. By the 1900s, it became an infantry battalion headquarters, with fourteen officers and 423 other ranks and was used for rifle training.

Garrisoned during the First World War, it then lay empty until 1938, when it was used as the Territorial Army Passive Air Defence School, before being used as the Army Gas School at the start of the Second World War. From 1942, it was used as accommodation for the US Army in the build-up to D-Day. Since then, the fort has remained part of the defence training estate and is still used by the Royal Marines, with many of the rifle ranges located here sloping steeply towards the sea.

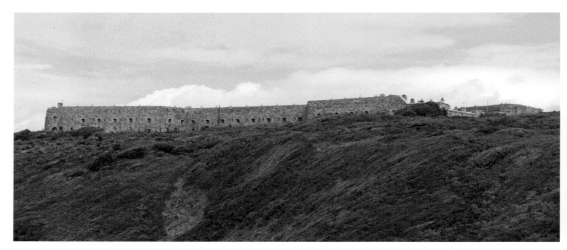

A distant view of Tregantle Fort from the coastal path. (Courtesy of Ben Smitheon CC BY-SA 2.0.)

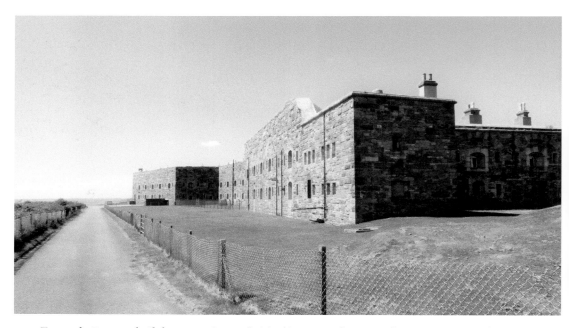

Tregantle Fort was built between 1859 and 1865. (Courtesy of Ben Smitheon CC BY-SA 2.0.)

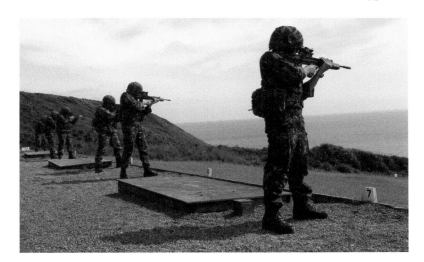

Royal Marines from
42 Commando on
the rifle ranges
at Tregantle Fort.
(Courtesy of
Open Government
Licence 3.0.)

Whitsand Bay Battery

Work started on Whitsand Bay Battery in 1889 and took just over five years to complete.
A battery of three 12.5-inch rifled muzzle-loaders and two 6-inch breech-loaders was
constructed near Stone Farm at the top of Tregonhawke Cliff. To protect the land from

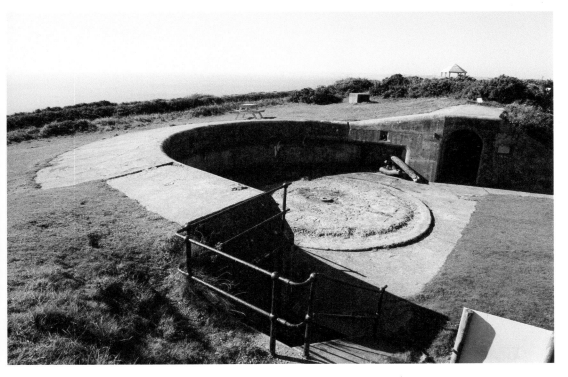

Gun positions at Whitsand Bay. (Courtesy of Ben Smitheon CC BY-SA 2.0.)

Access to some of the old tunnels is still possible. (Courtesy of Ben Smitheon CC BY-SA 2.0.)

attack, it was surrounded by a ditch, three machine-gun caponiers and accommodation for forty men. Although garrisoned during the First World War, it was disarmed in 1920, and during the Second World War was used for radar training as part of the Coast Artillery Training Centre, Plymouth. Today, Whitsand Battery is open to the public as a caravan park, and many of the original features can still be seen – although the ditch has since been filled.

Acknowledgements

Researching the history of the place you grew up and spent your childhood is an exhilarating and time-consuming process that has allowed me to rediscover new sights, sounds and stories. In this day and age, it is possible to do a lot of research online, but nothing compares to actually heading out and exploring things for yourself. Only then, when you see the history in its original environment, does it start to make sense. Investigating the different aspects of this book has led me to find out some incredible things and meet a number of wonderful people, all of whom have been willing to share their knowledge and expertise, and this is so important in passing on the history of our communities to the next generation. Some of these things I already knew and being reminded of them made me think how lucky I was to grow up exploring this fantastic county. Other things were new to me, and what is clear is that there is history lurking everywhere in Cornwall.

However, this book has not been without its challenges. Condensing the illustrious history of Pendennis Castle for example, a fortification steeped in this county's military heritage, is difficult, and inevitably I have not been able to write about every single aspect of some locations. Nor has it been possible to write about all the individual stories or events that have unfolded over the centuries. It has also been very difficult finding out about some of the older locations, such as those from the Iron Age, as often there are no remnants of the actual structures remaining, or they have been built on top of by more recent structures due to the prominent location. Indeed, the Second World War features heavily as it is the most recent conflict and many of these structures used pre-existing features as its base.

I need to express my gratitude to the organisations, people and photographers who have kindly shared their knowledge and allowed me to use their photographic work in my book, particularly Richard E. Flagg from UK Airfields.

I would also like to thank Nick Grant, Nikki Embery, Jenny Stephens, Becky Cousins and all at Amberley Publishing for their help in making this project become a reality, as well as my parents, friends and wife Laura and young sons James and Ryan, who accompanied me on many wonderful trips across the length and breadth of Cornwall, a county with beautiful scenery and a rich military heritage.

Kernow onen hag oll!

About the Author

Andrew Powell-Thomas writes military history, local heritage and children's fiction books. He regularly speaks at events, libraries, schools and literary festivals across south-west England and lives in Somerset with his wife and two young sons. With more books and events planned, it is possible to keep up with everything he is up to by following him on social media, YouTube or by visiting his website:

www.andrewpowell-thomas.co.uk

Andrew's other titles available with Amberley Publishing include:

The West Country's Last Line of Defence: Taunton Stop Line
Somerset's Military Heritage
50 Gems of Somerset
Historic England: Somerset
50 Gems of Wiltshire
Devon's Military Heritage
Wiltshire's Military Heritage
Castles and Fortifications of the West Country
50 Gems of Jersey
Channel Islands' Military Heritage